SUZANNA ROSA MOLINO

# Baltimore's
# LITTLE ITALY

*Heritage and History of The Neighborhood*

THE
History
PRESS

Published by The History Press
Charleston, SC 29403
www.historypress.net

First published 2015

Manufactured in the United States

ISBN 978.1.62619.814.2

Library of Congress Control Number: 2014955494

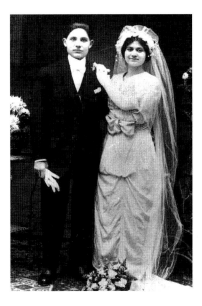

Luigi and Annina (Tana) Molino on their wedding day, 1914. *Author's photo.*

In memoria dei miei nonni:
*Annina (Tana) e Luigi Molino
da Vasto, Abruzzi, Italia*

*Antonica (Cabras) e Giovanni Mossa
da Luras, Sardegna, Italia*

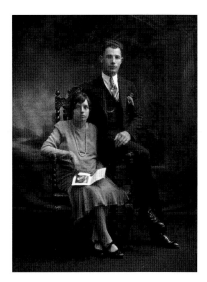

…e mia zia e lo zio:
*Angela (Culotta) and John "Jay" Molino
of 410 South Eden Street, Little Italy*

In onore dei miei genitori:
*Gina (Mossa) and Louis S. Molino Jr.*

Wedding portrait of Antonica (Cabras) and Giovanni Mossa in Sardinia, Italy, 1928. *Author's photo.*

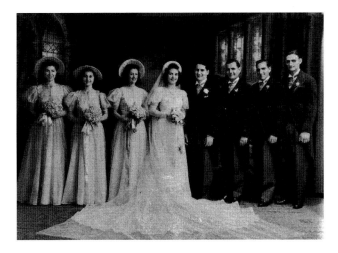

Since birth, the late Angie Culotta Molino (the bride) was a resident of Little Italy for about eighty-six years; she died at age ninety-three. She and her late husband, John "Jay" Molino, lived in the neighborhood for sixty-five years and were most active in the parish and Sons of Italy Lodge. *Courtesy Gary Molino.*

# Contents

# CONTENTS

# Why I Needed to Write This Book

L ittle Italy isn't just a place. It has a pulse—a heart that beats on its own. Like countless others who visit and live in the quaint community, I have no willpower to resist its allure. The small enclave has seduced me into lingering there for hours, luring my Italian soul into its clutch. I actually feel sad when I leave Little Italy to drive the thirty minutes home.

Yet it is not the delectable food of the restaurants and pastry shops that dangle temptation, although those alone are seductive. It is the passion and fascination for my heritage and the friendly born-in-the-neighborhood Italians, with their legends buried beneath the cement sidewalks. Behind the walls of the aged formstone row homes, lined up block to block, are tales that go back a century and a half.

One of my biggest delights in writing about Little Italy is to say it's still there. A 1974 book by Gilbert Sandler, *The Neighborhood*, offered quite a glum forecast for the community. But the end that he predicted hasn't happened. Little Italy perseveres.

My earliest memories of the neighborhood are of visiting 410 South Eden Street in the skinniest house I had the pleasure of exploring as a kid—the home of my father's brother, Uncle John "Jay" Molino, and my Aunt Angie (a Culotta born in Little Italy), two people who were an integral part of the neighborhood tapestry for more than sixty-five years.

My favorite characteristics of their elongated "shotgun" house was the exterior tunnel running between the street and their backyard—a dark, cool space that provided a source of joyful play for us little Molinos as we bolted

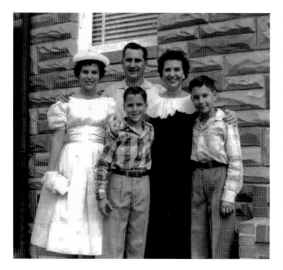

Molino family of 410 South Eden Street in 1957. *Left to right*: Carol Ann, John (back), Johnny Wayne, Angie and Gary. *Courtesy Gary Molino.*

in, out and through it. Inside the house was my second-favorite feature: a magical spiral staircase that led up to two more levels, one housing Aunt Angie's "mystery attic," where she had stored a multitude of treasures purchased around the world, including dolls, music boxes and knickknacks.

The house contained all I needed to feel Italian: a cozy kitchen spurting lasagna out of its oven, a dining room table laden with homemade Italian cookies and a house packed with our loud, loving Italian family, with me laughing at the punch line of an Aunt Angie joke I didn't understand.

My grandmother and grandfather Molino from Vasto, Abruzzi, and our Manna cousins once lived in that Civil War–era house *insieme* (together). A house that my brother Danny and his son, Paul, bought and renovated in 2005; they did the same with no. 412 next door. How pleasing it feels that they are holding on to the Molino part of the neighborhood and keeping alive our grandparents' name along Eden Street.

My gratification to have the opportunity to pen this book is *overwhelming*. Although I am optimistic that you will be rewarded with these glimpses of history, I am the one who collects the true reward: sharing Little Italy's history and the Italian immigrants' role in it. It allows me to greatly honor my four grandparents, who brought *Italia* to me.

I have visited Italy six times since 2001, and although I can't be there this minute, I can always be in Little Italy, where it feels familiar.

## About the Topics

No two writers would write a book identically. This is the way I did it. Here are two important thoughts I'd like to share.

First, the topics I chose to write about are mere *slivers* of the entire history of Little Italy—a snapshot, a glance, a meager peek into this historically strong neighborhood and its staying power. For it is truly unachievable to comprehensively cover a century and a half of history in such slim pages; we'd need a much thicker manuscript. For the restricted space granted to me by the publisher, I have included central components, plus other topics and stories that fascinated me.

There is a surplus of other elements—as well as additional family names—that I would have enjoyed sharing, for which there was simply no space. Countless families are connected to Little Italy's history, yet it is impossible to include them all, let alone *find* them all. Believe me, the fact that I could not include more names was on my heart and mind during the entire writing process.

There is a plethora of additional information, facts, tales, business and family names and photos that could make a second book. Yet please know that just because your family's name may not be mentioned on these pages does not make its significance to the history of The Neighborhood any less important, and it certainly does not erase its history. *You know that, and I know that.*

Second, the main challenge of researching, writing and relaying historical information is that details were not always recorded correctly initially, including name spellings. The next writer comes along and uses a piece of erroneous information unknowingly and then the next writer arrives and the next, until a fact has been quoted, cited and republished over and over, even though it was inaccurate or misspelled at the onset. As well, I was amazed at the variations surrounding time frames on the same topic. Which source to use when they each published different dates? Regarding people's memories, personal interviews did not always provide the truth or correct time frames. Different people remember things in different ways.

All in all, I put forth my greatest effort during the research process to include accurate information.

# *Prefazione (Preface)*

To my ears, the Italian language is the most treasured sound in the world. As a kid, I was accustomed to hearing it being spoken around the family. Italian was a natural taken-for-granted din in the background, as much a part of my childhood as the aroma of meatballs wafting through *la cucina* (the kitchen). Italian conversation erupted rapid-fire from the mouth of my grandmother, *Nonna Antonica*, as she conversed with her children: *mia mamma*, Gina, now eighty-one; *Zia Rosina*; and *Zio Martino*.

I listened to various relatives speak Italian as we visited them around Baltimore, usually sitting in the "second" kitchen in a basement, such as at the Mannas' house. I often accompanied *mia papa*, Louie, as we visited his aunts Mary and Jean, Uncle Patsy and his sweet tiny old aunt, *Zia*.

In *Zia Olga* and *Zio Giovanni* Bianchi's house on Baltimore Avenue, *paesani e cugini* (friends and cousins) came and went as quickly as Italian cookies were piled onto platters or lupini beans dumped into bowls. Unfortunately, I didn't pay much heed to the foreign sound of Italian. I didn't try to interpret it, and sadly, no one bothered to teach much Italian to my siblings or me. Periodically, a few vocabulary lessons made their way to our dinner table: *la forchetta* (fork), *la tavola* (table), *il coltello* (knife) or *il pane* (bread), but that's about it.

*Nonna Antonica* didn't bother learning much English because she didn't have to—nor did she seem interested. My cousins and I had great fun (at her expense) imitating her funny-sounding English words: *pock-ee-book, po-tay-toe cheep, strimp* and our personal favorite, *toik* (turkey).

My now eighty-five-year-old *babbo* (daddy), who learned Italian as his first language growing up in east Baltimore with immigrant parents, was instructed to bring English into the house. Eventually, he lost his ability to speak Italian fluently, although he understood entire conversations between *Mamma* and *Nonna*. His parents, Annina Tana Molino and Luigi Molino (like other Italian immigrants), craved to learn *inglese* (English), sometimes to avoid discrimination but mostly because they wanted to Americanize themselves.

My grandfather Luigi read comic books to learn, keeping them in his shoe repair shop at the front of the house on Fayette Street. He and my grandmother urged their children to go out to study English and bring it home. Parents of their generation, therefore, failed to pass along the Italian language in its entirety to their offspring.

In my first year of college, I studied Italian for two semesters but, regrettably, did not stick with it. More than twenty years later, in preparation for an eighteen-day family tour through Italy, including stops at my grandparents' villages, I studied Italian again through the Cultural Center for Italian Studies and at the Pandola Learning Center in Little Italy. (Ironically, the father of one of my instructors happened to be from the same village as my maternal grandparents.)

By birthright, I should speak fluent Italian! I am able to converse enough to comfortably call, e-mail and text message my cousins (*i miei cugini*) in Sardinia, Italy, yet I still yearn to speak Italian smoother, more fluently and without a Baltimorese accent. If only I had the power to turn back the clock to the days when I could have soaked up the language into my young being. What a dishonor to my ancestors that I didn't realize the significance of what I was ignoring.

At least I know where to go to hear and practice Italian—my mother's house, for one. And Sardinia, of course. Yet if I can't go to Italy that day, I *can* drive downtown to Baltimore's Little Italy. There at the bocce courts, for example, a handful of people speak Italian; some are natives of Italy, like Guy Lamberti and the Andracchio and Petrucci families. Walk around the neighborhood and bump into Joe Scalia, the Mannettas or Mimmo Cricchio Jr.—they speak the language. A handful of neighborhood chefs are Italian immigrants: Nino Germano, Carlo Vignotto, Germano Fabiani and Aldo Vitale. Pastry shop owners Bruna and Carmenantonio Iannaccone are from Italy as well.

Step into the Little Italy Lodge during one of its Friday night dinners, and some Italian immigrants may be there: Imelda Liberatore, Silvana Ferrante, Mike Girolamo and Maria Vitale. Even several non-Italians in the

neighborhood speak fluent Italian, such as Da Mimmo's Mary Ann Cricchio and Chef Masood, as well as Mary and Amedeo Ebrahimpour, owners of Osteria da Amedeo.

As an Italian American, I didn't ask to lose the language, yet I must respect my ancestors' desire to relocate here. And even though they and their fellow immigrants "set up houses" incredibly similar to their village homes in *Italia*, they continued with traditional food and customs and transformed the twenty or so blocks of Little Italy to copy their motherland. Still, this is America, and in America, we speak English.

We first-, second- and third-generation Italians are not as far removed as one might think from the immigrant families who arrived here with satchels and dreams. The Italian community of Baltimore has hoards of stories to share about arrival into the states—if not about themselves then about parents, grandparents and great-grandparents.

We do our best to reverse the assimilation process, to maintain rituals of our Italian heritage and to remember whose heritage we are living in America. Yet we no longer have our *nonni* to guide us the Italian way. They have all walked around the circle of life and now rest as God's angels. What we could have gained from the ones we never met—grandfathers and great-grandmothers—would have been priceless.

If one concept—and only one—was to be taught and passed along to us, at least it was the most vital of all: *la famiglia*. We stand proudly and collectively as aunts, uncles, cousins (first, second, third—the number doesn't matter), sisters, brothers, mothers, fathers, nieces and nephews. Many of us have stayed in one place all of our lives—the state in which our ancestors chose to settle. And some have remained in *la paesa* (the town) where it all started: Baltimore's Little Italy.

# *Riconoscimenti (Acknowledgements)*

*GRAZIE TANTO* to each person in Baltimore's Italian community who contributed to the formation of this book. Your comments, quotes, anecdotes, information, interviews, photographs, publications, e-mails, calls, Facebook posts and memories were needed and enormously appreciated. Extra credit is offered to photographer Tom Scilipoti; Carmen Strollo; my mentor, Roxanne MacDougall; my cousin Gary Molino; and my incredibly responsive and pleasant commissioning editor at The History Press, the splendid Hannah Cassilly. *Grazie e bravo a tutti*!

A whole bag of dog treats is tossed to my pooch, Razer, who good-naturedly lay under my desk daily during the weeks and months of writing, waiting for me to jingle his leash. Lastly, a special thumbs up to my tolerant hubby and kids, who lost me in my home office for hours upon hours as I barely picked up my curly head to cater to them. I love you, *mia famiglia*—you are my everything.

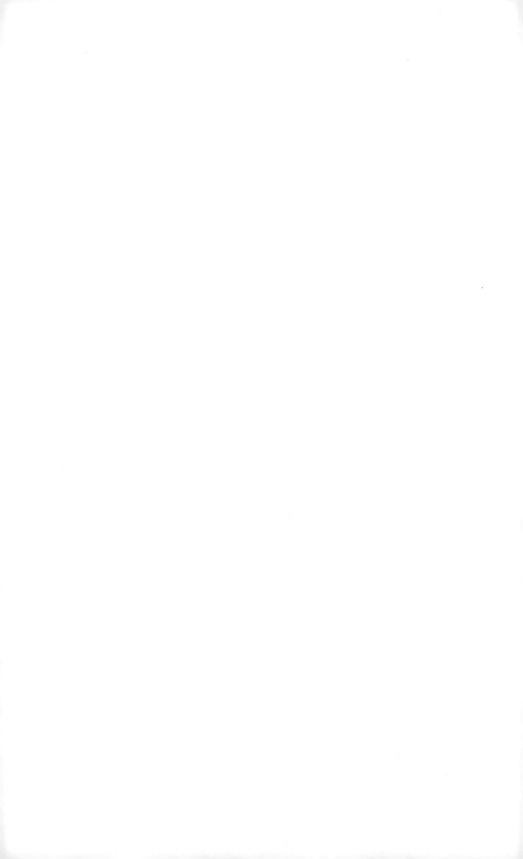

# Chapter 1

# How Little Italy Evolved

*That single one-way steamship ticket to America…contained the hopes, dreams, and very often the entire life's savings of many Europeans…carried them by the millions…across the Atlantic into the land of promises.*

–Italian Times, *1986*

Picture a mammoth ocean wave, a wave that started its journey in the 1800s in the poorest villages across Italy and gained force as it rolled across the Atlantic. Millions of its elements crashed into New York City—Ellis Island, to be exact—spewing out penniless peasants with skimpy possessions but a glint in their eyes envisioning an improved way of life.

*Come…create better opportunities and living conditions for yourselves and your children. Come…live in the land of plenty! God bless America!*

Why America? What prompted such a severe change in their lives? The United States beckoned to those who lived in destitution in overpopulated and war-stricken villages in their motherland—people who had experienced volcanic eruptions and earthquakes, who had endured backbreaking labor and appalling political conditions.

As the wave once again picked up energy, it continued a southern roll from New York, forming a crest and hurtling upon Baltimore—President Street, to be exact—as immigrants arrived by train.

The vision was a fallacy. Some found themselves existing in worse conditions than those in the country they left behind. Some hadn't planned to stay at all, heading west to find gold, yet they never left Baltimore; they took up lodging

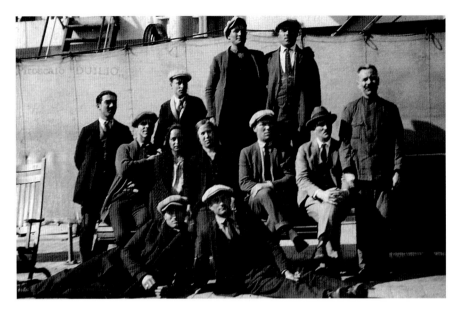

Pasquale Manna (left), age twenty-four, coming to America aboard the steamship *Duilio* in 1924. *Courtesy Johnny Manna.*

Francesca Vaccarino Caliri and her mother, of 913 Trinity Street. *Courtesy Osteria da Amedeo.*

in waterfront areas where ships were arriving and departing, in places such as Giacomo "Jack" Pessagno's boardinghouse and saloon opposite the President Street railroad station. Jack had arrived from Genoa in 1860. Or in Mary Cherigo's boardinghouse at 60 President Street back in 1875.

Immigrants found jobs such as stevedores, street pavers, shoe shiners, sewer diggers, railroad workers, bricklayers, musicians, organ grinders and furniture makers. Most hustled more than one job to earn additional money to send back to family in Italy. Work dominated their lives, even for the kids. "It was normal in those days to earn a livelihood in more than one way," wrote Angelo Pente in his 1991 memoir.

Others couldn't secure jobs because of heavy discrimination against Italians, so they invented ways to support themselves by opening up boardinghouses, saloons, fruit stands, confectioneries, barbershops and shoe repair shops in the first floors or fronts of their homes.

Raffaele "Ralph" DiLiello had been impressed by Ellis Island: "It was a beautiful place. So big! Tremendous! And the first thing they did for us was feed us…we ate macaroni and hardboiled eggs…must have been thousands of eggs piled up there! I never went back to Italy." (Today, the DiLiello name still has a presence as an insurance business on South High Street.)

Each day and week and year, smaller waves broke away from the original President Street residents, this time moving easterly block by block. *Piccola Italia* was forming—a smaller rendition of Italy, a "little" Italy. But the Italian wave wasn't finished rolling. Over the decades, it continued into Highlandtown, Dundalk, Patterson Park and the Belair Road corridor, until it depleted itself of immigrants.

In Baltimore's Little Italy, the Italians found one another and lived cohesively. Immigrants who had wandered there had established their own Italian village within twenty-some blocks and created scenarios that felt similar to the places they had abandoned on the other side of the Atlantic. "The night scenes along the streets of Little Italy are as if they were transplanted from the streets of Naples or Genoa," noted a 1911 *Baltimore Sun* story. "There are American trolley cars…and the streets are paved with Baltimore cobbles. But the language is the language of Italy."

Although Little Italy's official boundaries are Pratt Street to the north, Eastern Avenue to the south, President Street to the west and Eden Street to the east, over two centuries, the Italian population has expanded and contracted like the bellows of an Italian musician's accordion. Italians lived north of Little Italy up to Baltimore Street, including Lombard Street, which is named after Guardia Lombardi, a town in Italy.

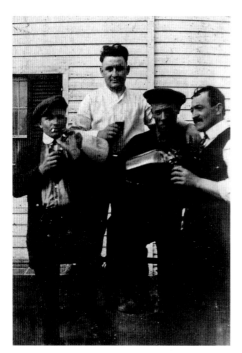

Romualdo "Romeo" Boggio (in white shirt) celebrates a new batch of homemade wine with *paesani*. Romeo arrived through Ellis Island in 1912. His daughter, Mary Ann (Boggio) Alcaraz, still lives in Little Italy in the house where she grew up. *Courtesy Ray Alcaraz.*

The Saint Leo's Church 1881–1981 anniversary book mentioned boundaries as far east as Broadway: "So many immigrants were pouring in that Little Italy could not hold them all. Other Italian neighborhoods were in various stages of development in Highlandtown, along lower Park Avenue and around the Belair, Lexington, Hanover and Cross Street markets."

Yet all were lured initially to America with one incentive: they were told that this magnificent country would offer a better way of life for the family. Men usually arrived first. They sweated and labored and pinched pennies, and with their limited capacity to speak English, they accepted any job, no matter the stench, danger or task. They did this not to eventually return to *Italia* but rather to send for their wives and children.

By the 1870s, almost half of the neighborhood's population was Italian. Mass emigration after 1880 from Italy began in Abruzzi, Molise, Sicily and Campania. Others came from Piedmont, Naples and Calabria—the tip of the boot—and from the picturesque island of Sardinia, such as Antonica and Giovanni Mossa (the author's maternal grandparents, who first settled in Brooklyn, New York, and then moved to Baltimore).

By the 1890s, Baltimore's Italian population was growing tremendously as Italians became the largest of immigrant groups in the area. They spoke varying dialects from their European villages, and when one couldn't understand another, they reverted to basic Italian. In the early 1900s, some say even up to 1920, Little Italy was almost exclusively Italian; practically every house on both sides of the street was owned by an Italian family.

Collectively, they could adapt to their new lives in America, fight homesickness, exist in a self-contained community and observe parallel customs. In case of an emergency, such as when a *mamma* took ill, help with food and laundry arrived easily; when a *papa* found himself out of work, a *paisano* (villager) might lend him cash or help him find work—a merchant would extend store credit for the time being.

Together, in Little Italy, the people lived as one large extended family unit in which everyone knew one another.

## BEFORE THE ITALIANS

*Who can forget the pickle barrel? Filled with crunchy pickles and brine, awaiting your trusty hand to pick one up, five cents.*

*–Angelo Pente*

The neighborhood was not always Italian, and it wasn't always called Little Italy. Previously part of Jones Town (today written as "Jonestown"), it was laid out in 1732 and named after an Englishman, David Jones, who built a house on the water bank of the Jones Falls, also named after him.

Since German, Jewish and Irish immigrants had settled the area earlier, it was then called "Mechanics Row," characterized by the German artisans who arrived by ship and settled into Baltimore—skilled craftsmen of watches, ironwork, blacksmithing, carpentry and other trades. The area was a melting pot of nationalities that also included Lithuanians, Russians, Polish, English and some Chinese. In his book *Rosaria's Family*, Andrew Lioi (neighborhood native and Italian immigrant) referred to the neighborhood as "a league of nations."

Those ethnic groups eventually moved on to other parts of the city as Italians bought or rented most of their properties. In time, the community transformed into a nearly all-Italian neighborhood and was dubbed "Little Italy."

While the Jewish dominated, several synagogues and non-Catholic churches dotted the neighborhood, specifically a synagogue on the corner of Stiles and High Streets, the Orthodox Beth Hamedrosh Hagadol Agudas Achim (1899–1935). Its front door faced Stiles, and a black iron fence surrounded the building. Before it was a synagogue, the building housed the High Street Methodist Episcopal Church (1844–99).

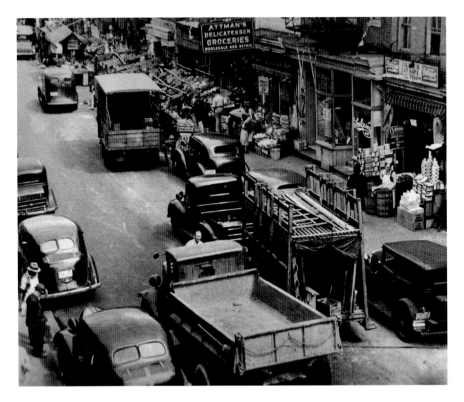

Jewish vendors' signs on Lombard Street, nicknamed "Corned Beef Row," in 1930: Attman's Delicatessen, Smelkinson's Bakery and Jake's Delicatessen. Nearby were Ginsburg Produce, Eli's Produce and Holzman's Bakery. *Courtesy Attman's Deli.*

The Vaccarino family, original owner of the Sun of Italy brand, next acquired the synagogue. Later, they sold the property and the brand name to the Pastore family, who used it for an office and warehouse. Before the building was demolished, items of value were offered to the Jewish Historical Society. Mimmo Cricchio eventually acquired the property; today, it is a private parking lot for Da Mimmo restaurant and the locale of the Open Air Film Fest.

About one block east of the present-day Little Italy Lodge was the Shomri Hadath (Orthodox) Congregation (1896–1935), where townhouses exist now. One block north of Saint Leo's Church was the Adath Yeshurum Orthodox Congregation at 127 South Exeter Street (1895–1948); that structure has disappeared as well.

At 910 Trinity Street, to the left of the former Panino's Restaurant (formerly DeNittis; a Panino's sign still hangs at the corner) was the Trinity

Evangelical Lutheran Church, a German parish in existence between 1839 and 1920 and dating back to the early 1800s as the Trinity Protestant Episcopal Church. "The bells would chime, and the organ playing sounded as though you were in heaven," said the late Ellen McGarry Welsh about growing up next door.

A 1902 *Baltimore Sun* story names 231 South High Street (current site of Amiccis Restaurant) as the Hebrew Children's Protective Society, an orphanage and asylum for Jewish children. Amiccis co-owner Roland Keh joked that "now it's my asylum."

Still standing along Lloyd Street several blocks north of Little Italy is the 1845 Greek Revival–style Lloyd Street Synagogue, one of the oldest synagogues in the country; it's no longer an active congregation but is occasionally used as a rental facility for bar/bat mitzvahs and weddings. Nearby is the active B'nai Israel Synagogue of Baltimore, built in 1876. Between the two buildings is the Jewish Museum of Maryland, founded in 1960 to save and restore the historic synagogue.

Common was the job of *Shabbos goy* for many Italian children in the neighborhood, hired by the Jewish to light fires and gas stoves on the holy Sabbath, when it was forbidden for Jews to do so. They would work a particular block in the neighborhood, and on a good day, they pocketed twenty-five cents in pay. "I was a *Shabbos goy* who lit up the lights and gas stove for the synagogue on Exeter Street at sunset on Friday night," said Andrew Lioi, eighty-nine, who was born in Italy in 1925 and came to the United States five years later.

So where did all the Jewish people go? That aforementioned rolling wave affected their ethnic cluster as well. As they became increasingly successful in business, they created new Jewish neighborhoods in other city and county locations, although Jonestown remained a Jewish neighborhood into the 1960s.

"The northwestern migration was not all Jews at once and was not just because of their increased wealth," said Trillion Attwood, program manager for the Jewish Museum of Maryland, "but also to create a separation between the Jews who had assimilated and those who had only just arrived." The migration to the Park Heights/Pikesville area in Baltimore happened later in the mid-twentieth century.

Historic Jonestown today marks a smaller area north of Little Italy along Lombard Street and includes the historic Shot Tower, Carroll Mansion (popular with Little Italy's youth between 1929 and 1954), Saint Vincent de Paul and Lloyd Street Synagogue. Although now predominantly an

African American neighborhood, it was once heavily packed with Jewish merchants—patronized by Italians and employing some Italians.

"From Exeter Street to Central Avenue there was a special atmosphere. Crates of live chickens, dressed poultry suspended from wall hooks, loads of vegetables and fruits spread out over the pavement—what a sight!" wrote Angelo Pente about the Lombard Street Market in "Jewtown."

> *The delicatessen stores specialized in pastrami and corned beef, all sold hot. Stones' Bakery was a place where rolls and bagels could not be baked fast enough. Especially on Sundays many would stand in line awaiting the next batch. On the north side of the street, the Russian-Turkish baths, frequented almost exclusively by Jewish males, did a big business. Yes, Italian stores were there also: Pastore's grocery, Garofolo's fruits and many smaller stands selling mostly vegetables. Also nearby was the Tulkoff's horseradish plant. Along this "avenue," you could purchase practically any necessity, from a kosher pickle to dressed chickens to a pastrami sandwich; clothes, shoes, pots, pans, or to sit down to eat your favorite Jewish meal.*

Italians and Jews not only shopped in one another's stores, but they also mingled on the streets and their children played together. Some married one another. It was a fine merging of cultures and a distinct Jewish-Italian connection. "This was brought about because the Jewish merchants learned basic Italian phrases to better serve their customers," said Lioi. "The Italian people would frequent the stores to buy live chickens on Lombard Street, as did the Jewish people. The Italians who worked in the [Jewish] tailoring factories had to learn about their bosses and culture."

Lioi's mother, Rosaria, shopped for bargains at two popular Jewish clothing stores, Faiman's and Bob's, pointing out to the shop owners, "I gotta six children. Give it to me a little cheaper." It worked, to an extent, as a two-dollar dress for her daughter Catherine or a dollar-and-fifty-cent pair of pants for Andrew would be discounted by ten to fifteen cents.

Today the Attman family still operates its popular New York–style delicatessen at its original location at 1019 Lombard Street, with its old walls of the "Famous Kibitz Room" spattered with black-and-white vintage photos depicting the era when Lombard Street was *the* place to shop. "Seymour Attman Way" is an added street sign nearby on the corner of Lombard and Lloyd Streets, a friendly tip of the hat in memory of a Jewish family who wouldn't quit their neighborhood in spite of the modern changes that have surrounded it.

Yankelov Poultry House, Lombard Street. Jewish vendors killed and dressed live chickens, ducks and turkeys for customers. *Courtesy Attman's Deli.*

Since 1915, their family tradition has continued, with Marc Attman now at the helm, although the building that houses the deli stands solo along the once industrious blocks of "Corned Beef Row." Sad, empty lots surround it, and across the street, newer housing faces it. No more market, no more stalls and no more cacophony of chickens or feathers floating in the air.

Yet today's patrons and dedicated customers of all nationalities still find that tiny wedge of a deli on Lombard Street and wait in long lines with watering mouths. It is inside where they will command Attman's famous hot piled-high sandwiches and, of course, lasagna and Italian subs. After all, tradition is tradition.

# Chapter 2

# Saint Leo the Great Church

## Anchor of "The Neighborhood"

*Generations of Italians have been baptized, married and buried from the venerable old church, with its characteristic bell tower visible from everywhere in Little Italy, serving as a beacon to call the faithful.*

*—Joe D'Adamo*

*Saint Leo the Great Church has been placed on the National Register of Historic Places by the U.S. Department of the Interior.*

A long with their skimpy possessions, a few lira and scruffy travel cases, the Italians also brought to America their sturdy Catholic faith. Once settled in Baltimore, they needed and wanted to put into action an even deeper devotion to God. They asked the Almighty Father to help them with homesickness, find employment and adjust to a new way of life in a strange territory.

The cornerstone laid on September 12, 1880, at the northwest corner of Saint Leo the Great represented a concept much more significant over the next 134 years than a chunk of concrete. For not only did that cornerstone provide a tangible foundation for the church's physical structure, it also provided an emotional foundation for Italians in Baltimore. Truly, Saint Leo's Church has been the nucleus of Little Italy since it was built, and that notion persists today.

Many former inhabitants of Little Italy say that one never really moves out of the neighborhood. As well, one can hardly shake a loyalty

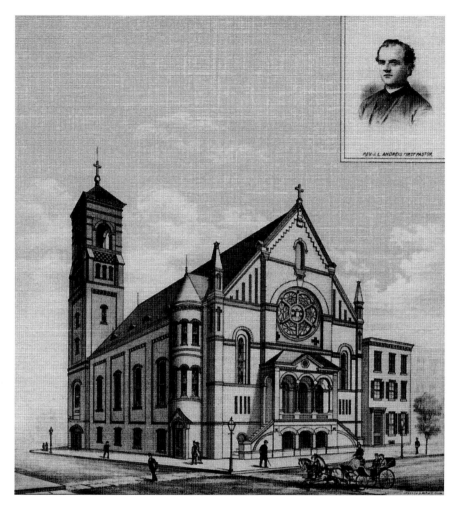

An 1880 sketch commissioned by Saint Leo's Church's first pastor, Reverend Joseph Leo Andreis (inset), to commemorate the laying of the cornerstone in September 1880 and dedication one year later on September 18, 1881. *Courtesy Saint Leo's Church.*

for Saint Leo's parish—it runs through people's veins as much as their Italian ethnicity. Parishioners of Saint Leo's are a classic depiction of family.

Even in advance of the neighborhood becoming completely Italian, the Archdiocese of Baltimore heard the Italians' wish. There were enough of them living in the city—and more Italians streaming in—to warrant building an Italian church. Saint Leo's was the first church in the state, and one of the first in the country, built exclusively for Italian immigrants.

Previously attending Saint Vincent's on Front Street, the Italian community was overjoyed to have its own parish.

Named after the heroic Pope Leo I (AD 440–461), who saved Rome from Attila the Hun, the church also honored the then reigning Pope Leo XIII. Archbishop James Cardinal Gibbons predicted that it would "become the social and spiritual heart of Little Italy"—he must have been clairvoyant.

Pope Leo had sent a monstrance from the Vatican that was used at the first Mass in Little Italy on January 23, 1881. The church wasn't even finished, yet the new parishioners (including non-Italians as well) were so ecstatic to have their own place of worship that they couldn't wait to begin. They pleaded with the new pastor, Reverend Joseph Leo Andreis (who transferred from Saint Vincent's), to say Mass. Orders were given by the archbishop that Masses were to be said in Italian only. The official dedication took place later in September.

In the history of the parish, about seventy-five pastors have taken the helm, with one priest, Father Louis Lulli, serving several terms. For more than one hundred years, the parish has been staffed by the Pallottine fathers, currently by pastor Father Salvatore Furnari, who came to Saint Leo's in

Clergy in front of Saint Leo's Church, 1937. *Courtesy family of Rose Quintilian Strollo.*

2006 as associate pastor under Father Mike Salerno. About four hundred families are currently registered.

Naturally, over the decades, the church has encountered cosmetic alterations in the way of restorations and improvements. Yet what has never changed is the rock-solid community of organizations, activities, parishioners and volunteers bonded in faith who generously donate their money, talents and time to keep Saint Leo's as great as its name.

# SAINT LEO'S FIRSTS

First cost, 1880: Archbishop Gibbons bought three lots at the corner of Stiles and Exeter Streets for $25,000.

First construction: builder, Edwin Brady; architect, E. Francis Baldwin, who designed Saint Leo's in a curious mix of Italianate, Romanesque and classical elements.

First pastor, 1881: Reverend Joseph Leo Andreis, native of Turin, Italy, who served for twenty-two years until his death in 1903.

First Mass: January 23, 1881.

First altar boys: Eugene Pessagno and Frank Valentini.

First children baptized: Leo Francis Bacigalupo and Eugene Leo Pessagno, during the first Mass.

First funeral: March 12, 1881, for Carlo Antonio Chiesa.

First Confirmation ceremony: January 28, 1883, by Archbishop James Gibbons, with a group of twenty-seven boys and forty-two girls.

First assistant pastor: 1903, Reverend Thomas J. Monteverde (ordained in 1890, died in 1905), son of Genoans.

First organist: Mary "Minnie" Malloy, who held this position for more than half a century; following her, and serving for forty-nine years, was Elizabeth D'Adamo Broccolino.

First Saint Anthony Festival: June 13, 1904.

First order of priests: 1909, Italian-based Pallottines of the Immaculate Conception Province.

First electric lamp installed: 1917.

First Mother Superior: Sister Mary Margaret.

First Little Italy Little League: 1957; its first commissioner was Lou Catalfo.

First Girl Scout Troop: 1965.

First Pizza Dance: 1966.

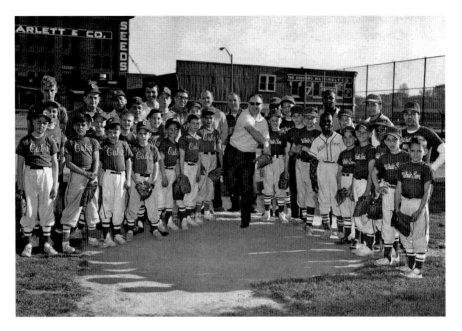

The first Little Italy Little League in 1957 included four teams: Cubs, Yankees, Cardinals and White Sox. Sponsors included Kelly & Poggi's Italian Pharmacy, Della Noce Funeral Home and Bagby Furniture. *Photo by Thomas C. Scilipoti.*

## RESTORATIONS AND IMPROVEMENTS

1883—organ, pipes, benches and carpeting installed

1888—church redecorated

1939—indirect lighting system; polychrome Stations of the Cross installed

1940—new Shrine of the Miraculous Medal dedicated and blessed, designed by an assistant pastor.

1949—refurbished Sanctuary with new marble altars and rail (quarried from Carrara, Italy)

1954—mural painted in Sanctuary depicting Saint Leo in glory; roof and interior repaired; rectory renovated

1963—air conditioning installed

1990—elevator installed to assist elderly and help with transfer of funeral caskets

1991—air conditioning overhauled

1993—restorative repairs to original organ

1997—interior of sanctuary and church painted; new kneelers and carpet added

1998—three niches built to hold statues; organ and pipes restored

1999—new air conditioner and ceiling

2000—gold-toned Saint Leo statue placed in outside niche above steps; air conditioning added to parish hall

2001—exterior of church painted; windows and brick limestone in tower replaced

2006—roof replaced

2012—Saint Lucy statue restoration

2014—exterior repainted; outside church hall door near alley replaced with Spanish cedar handcrafted door

2015—church organ restoration

# NOTEWORTHY FEATURES

*Murals and Paintings*: The noted artist Louis Jambor of New York began painting above the altar *The Glory of Saint Leo the Great* in March 1954, but he fell ill. After his death, Earl C. Neiman, also of New York, completed it in August 1954. The Corasaniti brothers donated the freestanding altar under the mural. Paintings of the Nativity and the Resurrection appear on the lower curved walls of the semicircular apse. The south rear wall of the church displays a painting of the Annunciation.

*Mosaics*: The inset colorful mosaic on the right altar railing reads, *Carita Christi Urget Nos*, meaning, "The love of Christ urges us on," the motto of the Pallottine Fathers. The mosaic on the left altar railing is the coat of arms of Cardinal Lawrence Shehan and reads, *Maria Spes Nostra*, which means, "Mary is our hope." Two additional mosaics on the exterior walls of the church, on each side of the steps, depict Saint Anthony and Saint Gabriel.

*Calvary scene sculptures*: In 1883, Father Andreis visited Europe and brought back several works of art to display inside the church, including Mary and Saint John the Evangelist sculptures on the Calvary scene that still stand today under the crucifix. Other paintings that he purchased no longer exist.

*Statues*: A close likeness of Saint Vincent Pallotti stands to the left of the altar next to Mother Mary and is more than one hundred years old; in his hand is a Mary icon. Padre Pio's statue along the left wall was a gift from the people of Province of Benevento, Italy. Saint Leo's Church owns one of his relics, a glove. (As well, it owns relics of Saint Francis Xavier, Saint Anthony of Padua and Saint Vincent Pallotti.) The Saint Leo the Great statue was a gift from the artist. The statues of Saint Anthony (holding Jesus) and Saint Gabriel along the right wall go back to the turn of the century.

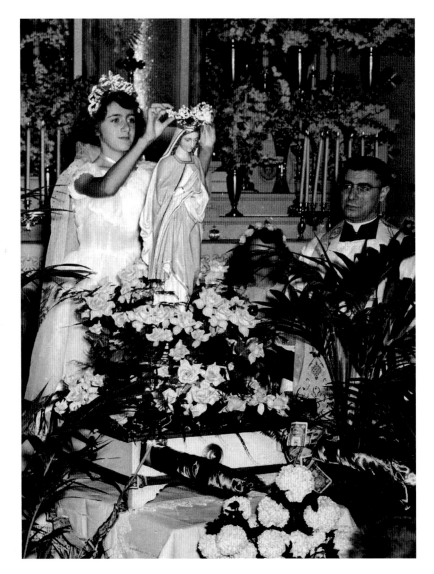

Annual crowning of the Blessed Mary statue (here in 1950), which continues at St. Leo's Church today on Mother's Day. *Photo by Thomas C. Scilipoti.*

Italians brought to America the devotion of these saints, and Saint Leo's continues to honor this feeling during annual festivals. Other statues include the Sacred Heart of Jesus, Saint Joseph and Saint Francis of Assisi.

*Church bell:* Weighing two thousand pounds and situated inside the *campanile* (the bell tower visible from many points in Baltimore), the original bell that

arrived on order was actually a mistake. Father Andreis had ordered *three* bells from Baltimore's McShane Foundry, yet only one enormous bell was delivered. It was hoisted into place with a pulley and ropes tied between it and a team of horses. Before radio was invented, the bell served as an important means of communication around the neighborhood, tolling solemnly during funerals and ringing joyfully during celebrations.

Since the bell's rope sometimes would break after repeated pulls, a rope fixer would have to climb to the belfry. In 1944, accompanying rope fixer Maurice Dell'Uomo and then pastor Father Louis J. Lulli reported the inscription on the bell: "From the rising of the sun unto the going down of the same, the name of the Lord is worthy of praise. (Ps. CXII, 3) Made by Henry McShane & Co. Baltimore MD, 1881."

Around the rim of the bell is a list of donor names. A church bulletin had reported that "it took a while to decipher the whole inscription since hundreds of pigeons used to make their nests in the belfry; the help of a searchlight was necessary. Indescribable dirt and dust had been accumulated up there."

Today, the Angelus bell is no longer rung by a rope; it automatically chimes the hours of 6:00 a.m., noon and 6:00 p.m. and plays music at noon and 6:00 p.m., skipping the 6:00 a.m. hour so as not to awaken sleeping residents.

*Church organ*: Still in operation in Saint Leo's is the original and durable 133-year-old French-style organ built by an immigrant German craftsman, Henry Niemann, one of the two most important organ builders in Baltimore and once a resident on North High Street. Of the forty instruments he built for area churches, few operational organs remain in Baltimore. Originally a pump model, altar boys had to pump its huge bellows to assist the organist. Its design is a traditional-style console with a keyboard cover and an attached keydesk. A simple casework houses hidden complex pipes to produce sound; the pipes vary enormously in size and are accessible through a hidden panel. Back in the day, the sole mechanic for the organ was Mr. Genovese. It was restored in 1993 and will be restored again in 2015.

*Original features inside the church*: Paintings of angels in the vaulted ceiling under Roman-style arches, the woodwork and the stained-glass windows made in Germany; and original pews (padding added in Father Mike's era). The rounded windows (four on the north side, and three on the south side) feature biblical designs with dominate shades of purple and blue. Notice the tiny size of the pew seats, an indication of the physical makeup of people in the 1800s. Associated Italian American Charities of MD (AIAC) donated new church kneelers in 1999.

*Clock*: A 1931 clock was discovered in 2014 on a shelf in the third floor of Saint Leo's School, manufactured by the Standard Electric Time Company in Springfield, Massachusetts, and put into service at Saint Leo's School on August 29, 1931. A service record card was found inside the clock with handwritten notations recorded between 1931 and 1945. One notation indicated that the clock included bells inside of it that rang in the convent, as well as inside and outside the schoolyard.

*Memorial bricks and inside plaques*: Dozens of inscribed plaques (a plan of Father Mike's) are hung throughout the inside of the church, memorializing, honoring and acknowledging various families, volunteers and donations. In the late 1990s and again in 2014, etched memorial and honorary bricks were added to the exterior wall under the steps of Saint Leo's Church by parishioners to acknowledge loved ones. The war/memorial plaques on the outside corner of the church are discussed later in the book in the chapter "At War."

# SAINT LEO'S ITALIAN ORPHAN ASYLUM, 1913–1957

*I just knew my mother wasn't alive and my father couldn't take care of us, that's all I knew.*

*—Nick Guarino*

Nick Guarino's *mamma* died when he was a year old. Until *Zia Concetta Tana* saved the day and took Nick into her home at 312 South High Street, he lived in Saint Leo's Italian Orphan Asylum. He was then almost ten years old. Until that time, it was a blessing that his two sisters and brother lived there as well, allowing the four siblings to interact daily. (Saint Leo's kept brothers and sisters together when possible, a unique move for this era but not, however, surprising among Italians, who rely strongly on family.)

*Opposite, top*: Saint Leo's Italian Orphan Asylum on Front Street was established to care for orphaned children throughout the parish and for some living in single-parent families. *Archives of Archdiocese of Baltimore, Maryland; Associated Archives at Saint Mary's Seminary and University.*

*Opposite, bottom*: Saint Leo's Italian Orphan Asylum kept brothers and sisters together when possible, a unique move for that era. Photo from 1946. *Archives of Archdiocese of Baltimore, Maryland; Associated Archives at Saint Mary's Seminary and University.*

The unfortunate part for Nick was that he "was a bad kid and got beat all the time," he said, "by Sister Augustine. Sister Antoinette—she was real strict, too." Even after eight decades, he easily names those two nuns out of six who wore habits "like big sailboats."

She pinched him, too, that mean Sister Augustine. "When I was mischievous, she used to pinch me all over." What did the baby of the family do wrong to deserve corporal punishment? "Once I walked over the top of the piano," said Nick. "That was bad."

In the 112 North Front Street orphanage a few blocks north of Little Italy, routine included rising early, dressing and lining up among the other forty children to march to chapel downstairs to pray the Rosary. It may have included a walk to Mass at Saint Vincent's Church next door at Fallsway and Fayette Street (Nick remembered Father Martin as pastor). Then it was back to the orphanage to eat breakfast and line up again so the nuns could release a spoonful of cod liver oil into each child's reluctant mouth. "Nobody liked it," remembered Nick, born in 1930 in Little Italy. "I used to try to spit it out."

The children then played outside until school started at Saint Vincent's, their only playground a small, empty brick-covered area sandwiched between the church and orphanage devoid of swings, toys or sliding boards. Chapel was a three-time portion of the orphans' day: morning, afternoon and evening. School was in session from 9:00 a.m. to 3:30 p.m. year-round. Chores were a part of daily life: Monday's laundry was done manually on washboards and tubs using handmade soap, and Tuesday's mending included sewing on countless buttons and darning shirts, pants and stockings. Sweeping and scrubbing floors, porches and the marble front steps left scant time for the youthful pleasures of being a kid before being shuffled off to bed at 8:00 p.m. "The nuns made sure we said our prayers. I didn't want to go to church. I thought I was a saint already," Nick said, laughing.

Closed off in separate quarters from the sisters of God, the children slept in large dormitory-like rooms with rows of beds. Nick remembered big rooms and big halls. Girls stayed in one dormitory and boys in another. The house had a library and a dining room for the children. The Pallottine Sisters of Charity taught eight grades.

Saint Leo's Italian Orphan Asylum was incorporated circa 1913 when Father Joseph Riedl, then pastor of Saint Leo's, noticed that there were many orphaned children in the parish and some living in single-parent families. He purchased and converted the buildings of Saint Vincent's Male Orphan Asylum & School, once rented for use as Saint Leo's School, seeking

financial support from prominent Baltimore Italians. There was lofty interest in the project.

In the new orphanage, seated at a bare table with candles providing the only light, the first meeting took place between the newly arrived sisters, the priest and the committee. The facility's poverty status was so obvious that the superior Mother Catherine asked Father Riedl for a verbal agreement that should the orphanage fail, he would assume responsibility and pay them $300 in cash so they could move on.

Parishioners of Saint Leo's often donated clothes and groceries to the orphans. In the initial days when there was not enough to feed the children, the sisters walked from house to house with baskets and begged for food.

For thirteen cents a day, a child could be fed (frugally at that), clothed, housed and educated. By 1947, it cost thirty-eight cents a day. Some families were simply too poor to care for their children, and some parents, like the shoemaker whose wife had died (Nick's *papa*), couldn't care for their children while they worked.

The same scenario put five-year-old Nicholas Anthony in the orphanage with his three (of five) sisters—Antoinette, Anna and Loretta—after their mother died in 1913. His father was unable to care for six children; Rose and Marie were older and were passed around between relatives. Anthony lived there for seven years. In a 1975 *Baltimore Sun* story, he said that he remembered seeing "happy children who lived in homes with their families and played in the streets…yet I was not part of their world."

Only once a month were parents permitted to visit; his father saw them sporadically. Any sweets visitors may have brought had to be shared with other kids not as fortunate to host relatives. Nicholas named a few fellow orphans: Joe Mascari, Sam Serio, Mike Piccarelli, Tony and Louis Battista and Joe Rochette. Various newspaper stories from assorted years cite the orphans in numbers: 1925, 67; 1931, 48; and 1947, 52 "and filled to capacity."

Charming features of the old orphanage building included balconies circling the yard on the first and second floors, wide steps and a large porch, as well as one amusing perk—it was situated close to the Central Police Station—that meant Christmas gifts for the children and an annual watermelon party hosted by the captain. A movie theater was nearby as well, and the orphans were allowed in free of charge. After being closed by the archdiocese, the orphanage was torn down around 1960. It had done its job well. The children were moved to more spacious facilities at Villa Maria in Towson.

Entertaining activities or not, Nick said, "I was happy to get out of there," even though he "never knew Mamma so I never knew what it felt like to have one." In describing his early childhood, it seems that Nick the boy was very accepting of his orphan status. Occasionally, the Guarino children would visit their father. "I didn't realize I had a father at first—we didn't know him well. I didn't know any better; I was too young. I just knew my mother wasn't alive and my father couldn't take care of us, that's all I knew."

## SAINT LEO'S SCHOOL, 1882–1980

*Raise the tuition. The community would help…let's hang on, and let's try. We don't want this school closed.*
*—Anna D'Amico in a 1978 Parish Council Meeting*

A year after Saint Leo's Church was established, Saint Leo's School held its first classes in a small wooden building on Stiles Street in September 1882. Along with the parish, it also aided in unifying the community. The School Sisters of Notre Dame took charge of the parochial school, with Sister Mary Margaret as Superioress; it was reputable throughout the city for its high academic standards. (Benedictine Sisters took over in 1972 and Pallottine Sisters in 1974.) There they instilled the Catholic faith as well as prepared Italian children for American citizenship.

The school building that exists today was completed in 1931 to replace the initial structures—a row of old houses badly in need of repair and without central heat and plumbing. Greatly overcrowded, a classroom held as many as fifty children.

Although it was difficult to ask families to pledge money for a new school in the midst of the Depression, Father Hector Messina and Sister Ursula somehow managed to secure pledges from enough generous neighbors to begin construction in 1930. Responding to a door-to-door campaign, Saint Leo's parishioners met the challenge. The school sisters hosted spaghetti dinners to help raise some of the funds.

Thomas D'Alesandro Jr. headed the building committee and secured a few contractors, such as Frank Pellegrini, to donate material and labor. The commissioned builder was Frank Marino. During construction, classes were temporarily held in Bagby's furniture warehouse on Fleet Street. The school reopened with four hundred pupils.

Saint Leo's School class of 1945, with Reverend Louis Lulli; the priest returned several times to serve as Saint Leo's Church pastor. *Courtesy Johnny Manna.*

Saint Leo's School fourth-grade class, 1938. *Courtesy family of Rose Quintilian Strollo.*

The new school building and next-door convent—to the tune of $53,800—was dedicated on November 29, 1931, during the golden jubilee of Saint Leo's Church. The elaborate celebration included throngs

of spectators, church dignitaries, politicians and city officials, an Italian ambassador and a number of celebrities. All accompanied Father Messina as he blessed the project and accepted an American flag from the Knights of Columbus to fly over the structures.

Tuition was raised from fifteen to twenty-five cents per week to help meet the cost for those who could afford to pay it; the school was free to those who couldn't. A discount was offered to families with three or more children at ten cents per child per week.

"The normal curriculum included reading, writing, arithmetic, geography, history, art and penmanship," wrote J. Vincenza Scarpaci in *Ambiente Italiano*. "In those days some children had difficulty with English because their parents only spoke Italian at home." After the Second World War, many of the returning servicemen married and moved out of Little Italy, said Scarpaci, the "suburban drift" of postwar America. For the most part, their parents, younger siblings and older residents remained.

Because President Truman's federal programs encouraged slum clearance and urban renewal, city planners constructed public housing projects along the outer perimeters of the neighborhood. Although some Italians were uprooted in the process, officials' mentality was "clean it up by tearing it down." The projects first housed white residents, said Scarpaci, but then "integrated, and then to mainly black families on welfare."

This change naturally decreased student enrollment at Saint Leo's School. As younger Italian families moved away, African American children were admitted into the school yet not welcomed by the Italian community. The nuns were forced to apply for federal aid, but it failed to increase enrollment. After Saint Leo's "became a drain on archdiocesan funds," said Scarpaci, and even after Italian American business and charitable groups stepped in to help, the Archdiocese of Baltimore closed the school in 1980. Neighborhood families fought it hard since Italian families held education in high regard.

"Saint Leo's School plays a key role in preserving the neighborhood's nationality. It is the center of the action," said Joe Scalia in a 1973 *Baltimore Sun* story about the archdiocese wanting to reorganize the school. Scalia, a native of Italy, still lives in the neighborhood, across the street from Saint Leo's School. In that same story, he said that Little Italy is "like a village" and that while other neighborhoods have changed their ethnic characters, his community has remained intact.

Saint Leo's School had graduated thousands of neighborhood students and others in the area. Still others attended Saint Vincent School on Front

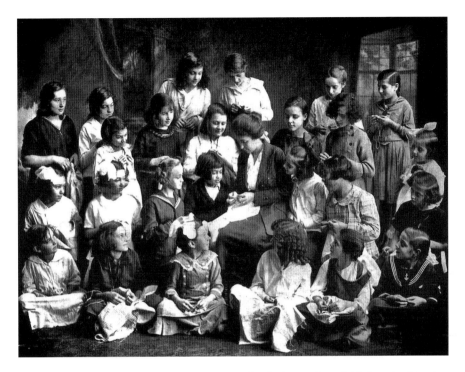

Saint Leo's School Sewing Class, circa 1900, consisted of second- and third-grade girls who made sewing bags, bloomers, aprons and handkerchiefs. The teachers were Miss Cook, Miss Koppa and Miss Ring. *Courtesy Thomas C. Scilipoti.*

Street or Public School No. 2 at Stiles and Lloyd Streets, now Stratford University, a culinary institute.

"One of the most difficult parts about having a parish in the city is not having a school," said Father Sal, pastor. "We're fighting an uphill battle."

Nuns in the 1930s like Sister Bertilla, with her big wooden ruler, wore full black habits with stiff white linen cloth across the brow, along the cheeks and under the chin. Sister Theophane was once Mother Superior and principal. Disciplining the children with physical punishment was accepted: face slaps, being beaten with things and blackboard head-banging—acts of cruelty no teacher today would try to administer nor any parents accept. In those days, parents not only supported the punishments, but they also respected the nuns for taking disciplinary action. As a result, there was little or no delinquency, and students respected teachers. Children also realized if they ran home with reports of punishment, their dilemmas would only double.

Memories and anecdotes about Saint Leo's School nuns do not paint a kind picture. The generic Catholic school student of decades ago can't quite link the notion of nun brutality with the fact these women were supposed to be faithful and loving servants of God.

Perhaps instilled "fear was a good motivator to do what's right," said Roland Keh, who grew up in the neighborhood; his parents still reside there. "I think the nuns knew that! Sisters Ursula and Cabrini [1950s to 1970s] were masters of psychological intimidation. There was some physical punishment—a slap on the rear or across the knuckles—but never anything that our parents wouldn't agree to. The large paddle hanging in the coatroom was a reminder of what could be. Just the threat of staying after school, cleaning erasers, blackboards and whatever they wanted you to do was enough punishment."

Jane DiFonso Dorsey thought the Saint Leo's School nuns "were the meanest nuns ever, and the priests weren't very nice either. Let's not forget Sister Cabrini, who I think might have been the wolf in sheep's clothing. I think Sister Trinita was about the nicest, but she had a mean streak."

Christine (Dell'Uomo) Dillow agreed. "I think Sister Trinita was the nicest, although she picked me up by my ears because I didn't kneel down to her liking during First Communion rehearsal. Going back in time can be so funny now…it wasn't funny back then." Still, Christine said she was "sad to see the doors close."

Bill Bertazon said that he witnessed "Sister Ernestine make Victor Santoro bite and chew on a bar soap because he said *sh--*." Bill's favorite, Sister Rosemary Leon, is now ninety-four years old and lives in Connecticut. The two stay in contact. "She still calls me Billy."

Sister Louis Mary carried a heavy bronze ruler and would hit your knuckles with it, remembered Anthony Ferrari. "Sister Ursula slammed my head against the blackboard because I did not understand fractions." (Supposedly, after disciplining a student, Sister Ursula went into the cloakroom to sob softly.)

Carmen Strollo remembered other nuns: Sister Trinita, Sister Louis Mary and Sister Joan Dirkin. "How come I always had to serve the 6:30 a.m. Mass?" he wondered. "It wasn't my fault I lived close by."

Yet the overall attitude among the former students was that Saint Leo's was a good school. "The nuns were great teachers," said Johnny Manna. "Forget the head-banging. We had a lot of fun times, too. A Christmas play in the hall was only one of the many good things the nuns did."

Saint Leo's School class of 1953. *Photo by Thomas C. Scilipoti.*

There were field trips to D.C. to visit the offices of Tommy D'Alesandro. A turkey raffle was held for a chance to win a freshly killed and dressed Thanksgiving turkey—raffles were five cents each.

Johnny brought the good to light even after recounting an anecdote of a fellow classmate nicknamed "Jap" (John Lioi) being hit with a "pointer" by Sister Laurentia: "He ran for the library. She gets him in the library. Closes the door. All you could hear were the chairs being knocked over and Jap yelping."

"Whatever they did or did not do," said Mary Bracken, "they taught us all very well, and I am happy that I had a Catholic education."

The sisters lived in the convent separated from the school by the schoolyard and depended on neighborhood residents' generosity for food, repairs and donations. (Today, the convent is occupied by Xaverian Brothers.) Often, schoolchildren ran errands for the sisters and helped with cleaning the school and church.

"A group of us scrubbed the wooden altars and railings, cleaned wax off of the rugs and vigil lights, cleaned vases and other things the sisters wanted us to do every day after school," said Lucille Scardapane

Jeannetta, who graduated in 1947. "We had to do it or our mothers would get mad. I can't say it was all work. Us girls [including Shirley Terzi Ciarapica] had a good time playing 'Boogie Woogie' on the organ and going up in the belfry with some boys, until we got caught. We were supposed to be cleaning. Father Dominick raised holy heck. We were just kids."

# HISTORICAL PARISH SOCIETIES STILL IN EXISTENCE

SAINT ANTHONY SOCIETY (1904): This society promotes devotion to its patron saint, Saint Anthony of Padua, and sponsors a major parish fundraiser, the Feast of Saint Anthony Italian Festival. After World War II, the society disbanded and was revived again in 1999 by Father Michael Salerno.

SAINT GABRIEL SOCIETY (1928): Founded by Bernardo Gabriel, Tony Zuccaro and Ignazio Tavono from the Abruzzi region as an expression of devotion to the saint. The society sponsors dinners, fundraisers and

Sister Trinita, Denise Giacomelli, Susan Culotta, Kathleen Rose, Jane DeFazio and other unidentified Communicants, 1960. *Courtesy Denise Giacomelli Loehr.*

activities that benefit Saint Leo's, specifically the Feast of Saint Gabriel Italian Festival.

SAINT VINCENT PALLOTTI SOCIETY/UNION OF CATHOLIC APOSTOLATE (originally established in the 1950s; began again in 1998): Its mission is to help those in need in and outside the parish community.

SODALITY OF OUR LADY: Originally affiliated with the Primaria Sodality of Roman College in Rome, Italy, the Sodality was established by His Eminence James Cardinal Gibbons of the Archdiocese of Baltimore in 1889. There is no recorded date at the parish as to when its Sodality began; however, it is decades old and continues to fosters in its members an ardent devotion, reverence and filial love toward the Blessed Virgin Mary. When the nuns of Saint Leo's enrolled their seventh- and eighth-grade students into the Sodality, they informed them that it was a lifetime enrollment. The Sodality oversees a Blessed Mary celebration at Saint Leo's, a timeless tradition that includes a Mother's Day Mass and the crowning of the statue of Mother Mary in church, followed by a procession with the statue and First Eucharist communicants through the streets of Little Italy.

Not historical, but important to note, is the Knights of Columbus Saint Vincent Pallotti Council No. 14535, which was formed within the parish in 2008. The group promotes unity, charity, fraternity and patriotism and is involved in many activities and fundraisings at Saint Leo's, including providing color guard at main events.

# EARLIER PARISH SOCIETIES AND ORGANIZATIONS

SAINT LEO'S CADETS CORPS (1916): Led by drillmaster Carlo Marbotti, this organization promoted patriotism and perpetuated the memory of Saint Leo's parishioners in World War I. The boys performed at processions and other special celebrations dressed in military uniform and toting wooden rifles.

SAINT LEO'S LYCEUM: First of three societies in the early days of Saint Leo Church, this social club existed for five years and consisted of young men who gave minstrel performances and plays in the church's basement hall.

SAINT LEO'S ATHENAEUM: The second society formed, this one served young boys of the parish as a preparatory school in training them for greater parish-related responsibilities to come.

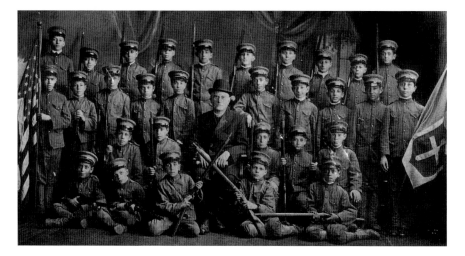

Saint Leo's Cadet Corps carried wooden rifles. *Courtesy Saint Leo's Church.*

SAINT LEO'S GYMNASIUM AND LITERARY ASSOCIATION (1891): This organization's objective was to provide moral, social and physical development of young Catholic men. In its 1901 tenth anniversary booklet, it notes part of its mission was "to keep them from digressing into forbidden ways, to the wreck of character, the loss of physical and moral strength, and the ruin of their souls." It began with twenty-eight members and by 1901 had three hundred members, which included boys and men from other parts of the city. A very important institution, the gymnasium on the third floor of the old school building was for members only and offered a track, a punching bag, a pool, handball and social affairs. An annual Field Day was held at Tolchester Park and a meet at Patterson Park. The gym produced Eugene Pessagno as a champion broad jumper; William Linney as a high jumper and hurdler; August "Americus" Schoenlein as a light heavyweight champion wrestler; and two world boxing champs, brothers Joe and Vince Dundee. It also trained locally popular names such as Mike Sipio, Larry "Killer" Marino, Mike DiCicco, Mike "Kid" Juliano (who had an extensive police record), the Transparenti brothers and "Buster Brown" Ronzini. The gymnasium was razed in 1930 as the new school was being built.

SAINT LEO'S CLUB (1895): This organization was housed in the gym and was founded by Father Andreis to provide a constructive outlet for the energy of neighborhood children and young adults. Club president was Dr. Joseph Valentini (who later became a politically influential

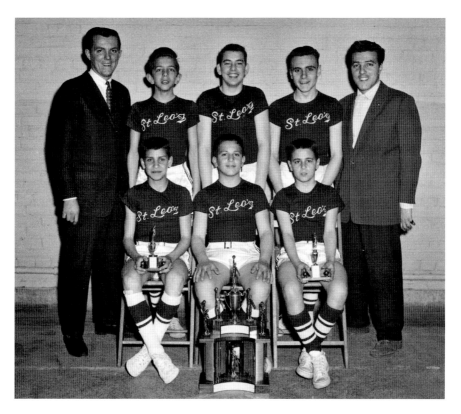

Saint Leo's School basketball team, 1960. *Top row, left to right*: Bob Zelkoski, Richard DiSeta, Jules Farroco, Marco Minnie and John Petti. *Bottom row, left to right*: Felix Bucci, Frank DiAngelo and Louis Campanella. *Photo by Thomas C. Scilipoti.*

Italian around Baltimore). The club became nationally known by the 1920s.

SAINT LEO'S CONFRATERNITY (1919): This organization was formed to promote spiritual welfare and encourage interest in church and school activities.

SAINT LEO'S FIFE AND DRUM CORPS (1941): This award-winning musical group made its first official appearance in the church's May procession; members wore white uniforms with maroon jackets, hats with maroon pompoms atop and capes and played instruments such as the fife, bugle and drums. At points, Mike D'Adamo was a lead bugler, and Tony D'Apice was a drum major. The group was initially led by Sister Rosetta and later taken over by Sister Laurentia. Some of the mothers, like Catherine Seminazzi, made the uniforms.

Other societies and groups that came to light during research include Christian Mothers' Sodality, Children of Mary (girls), Saint Aloysius Society

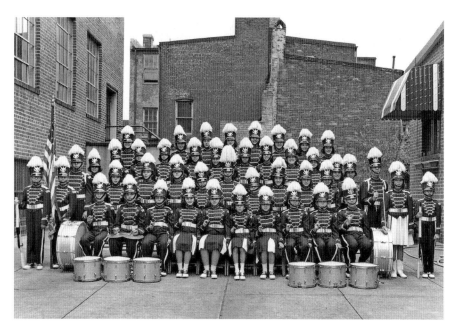

Saint Leo's Fife and Drum Corps (pictured in 1952) won first prize at the competition of New York State Fife and Drum Corps Association, and in 1956, it won first prize in the junior division of the National Safety Patrol Parade in Washington, D.C. *Photo by Thomas C. Scilipoti.*

(boys), Catholic Benevolent Legion, Saint Leo's Beneficial Society, Blessed Sacrament, Holy Rosary Confraternity, Souls in Purgatory, Saint Leo's Mother's Club, Confraternity & Parish Society, Saint Leo's Youth Group and Saint Leo's Girl Scout Troop.

## THE RAVIOLI IS STILL RAMPANT

*If you thought the concept of homemade was a thing of the past, then you haven't tried our ravioli. Saint Leo's spaghetti-ravioli dinners recall the aromas and tastes of mamma's kitchen.*

—*Father Sal Furnari, pastor*

Saint Leo's school and church have always operated hand in hand, like the spaghetti and ravioli with meatballs that are served during their twice-annual dinners. The school sisters, and the sisters who cared for the children at the Saint Leo's Italian Orphanage, initially hosted spaghetti-only dinners to raise money for the school and the orphanage, as spaghetti was an inexpensive staple.

Father Dominick Zaratti and Father Mario Schettino, 1958. *Photo by Thomas C. Scilipoti.*

The orphanage hosted its first spaghetti supper and bazaar fundraiser one year after it opened; this is believed to have set the pattern for continued spaghetti suppers. Thirty-three years later, a 1947 *Baltimore Sun* story promoted the dinner and indicated that it was hosted annually. In 1954, ravioli were added to the spaghetti suppers at the suggestion of then pastor Father Mario Schettino.

"The Cuneos, Brocatos, Azzaros and the Bacigalupos" were active with the dinners, said Nancy Azzaro, parishioner, "and many devoted parishioners and family members helped them. God bless them. Most of them are gone and should never be forgotten. The dinners at one time were in the middle of the week, and my father-in-law, Andy Azzaro ["Eight Ball" Andy], said to my mother-in-law, Crescentia [Bacigalupo], 'Why do you do this during the week? You will have more people and make more money if you do this on the weekends.' That's how that began."

Crescentia was ninety-eight years old when she died, a resident who "refused to leave Little Italy," said Nancy. "So many wonderful Little Italy people that are deceased who worked hard for the neighborhood and their church."

February 2014 was the first time in ages that Lucy Pompa, ninety-six, had missed the ravioli-making session in the school hall in preparation for the

event. In previous years, she had never missed a beat as the "Queen of the Ravioli," overseeing the dough making as dozens of volunteers handmade thousands of the square pasta.

"It was always a group. No one was the boss. We helped each other," said "Miss Lucy." "We did what Father wanted. There was a lot of hard work involved."

Today, ravioli- and meatball-making sessions in the school hall occur a few weeks before each dinner; eighty or so volunteers dig deep into the dough and ground beef to produce about fourteen thousand ravioli and approximately three thousand meatballs for each dinner. Held twice annually in March and November, the popular Ravioli and Spaghetti Dinners are large fundraisers for the parish. They transpire only because of the hundreds of devoted volunteers who plan, cook, serve, tend bar, wait tables, toss salad, bus tables, serve coffee and dessert and work game tables.

"Saint Leo's, a small church with a great *big* heart!" said volunteer John Kidwell.

## Recipe for Saint Leo's Ravioli Dough

*1 cup good-quality flour*
*3–4 eggs*
*½–¾ cup water*
*2 tablespoons olive oil (or less)*

Make a well with flour. Into it, put eggs, water and oil, which may be lightly mixed. Work flour and liquids together, carefully. "Don't just goosh it in," Lucy Pompa cautioned. "Work it in. If it's too dry, add an extra egg." Work dough until it begins to get firm and then knead vigorously for about 15 minutes. Knead until dough is not tacky—not hard, but easily handled. Let it rest, covered, for about 1 hour.

## Cheese Ravioli Filling

*1 pound ricotta*
*½–1 cup Romano cheese*
*1 egg*
*oregano, salt and pepper to taste*

Mix ingredients together and use to fill dough. If possible, let ricotta "stay" for a day to dry out a little. Fresh ricotta may be too thin; it may be thickened with a little cracker meal. Makes about 30 ravioli pies, or enough to fill a double recipe of dough.

To make ravioli, use a pasta machine; without one, roll out a long strip of dough about 4 inches wide on a floured surface. Stretch around the rolling pin until thin. Place about 1 tablespoon of cheese filling at two-inch intervals. Fold outer edge of dough over and, with hands, "cup" each ravioli pie to drive out extra air. Cut with knife or fluted cutter in between each ravioli and seal with tongs of fork in two to three places around edges. Move quickly so dough does not dry out. Cover after cutting and sealing. Cook ravioli for about 3–5 minutes in boiling water.

# WHY SAINT LEO'S HONORS SAINT ANTHONY WITH AN ANNUAL ITALIAN FESTIVAL

*That first procession which wound its way along the narrow, festooned streets of the parish. Practically everyone in Little Italy who could walk was in that parade.*

–Baltimore Sun, *1946*

It was the first significant historical event that Michael DiCicco remembered—the Great Baltimore Fire of 1904. "It was on a Sunday, [my father was] coming home from work. The fire was already started," he said as he set the scene in a 1979 Baltimore Neighborhood Heritage Project (BNHP) interview. "The wind was blowing towards us—the east, coming this way…it was so bad, old Pop, he got himself somebody's pushcart, the old family trunk and us three kids on the trunk and run us down to Broadway. We slept in the Armory for three days. He went back home with buckets to keep the sparks from catching fire to the roof. After three days we came back home and we could still see the smoke."

The Italians of Little Italy were terrified. They were certain that the determined fire would burn through their dearly loved neighborhood, homes and businesses—symbols of their toil, sweat and fulfilled dreams. So they prayed. Many gathered at the wall of the Jones Falls on a cold February day, facing the smoky sky to the west, and begged Saint Anthony to spare

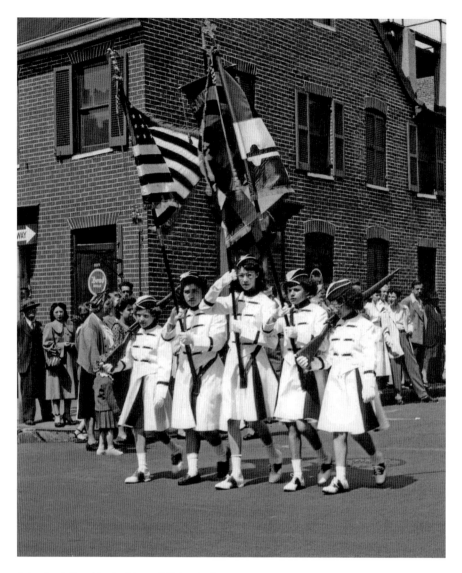

Saint Leo's Band in the Feast of Saint Anthony procession. *Photo by Thomas C. Scilipoti.*

Little Italy. Several men raced back to Saint Leo's Church to grab the saint's statue and returned to the restless residents in prayer, led by then pastor Reverend Thomas Monteverde.

"*San Antonio! San Antonio!*" Everyone could only hope that the saint was listening to the outspoken cries and shouted petitions. Baltimore was burning up west of the water; the fire gutted everything in its malicious path.

Genardo Fullano, one of the two founders of the Saint Anthony Society, relayed the story in halting English and with the aid of an interpreter to a *Baltimore Sun* reporter in 1946 about that frightful night during the fire: "Most of the people had gone to Highlandtown. The few of us left went into Nick Barone's saloon on President Street. The big flames were coming closer. We were not in the saloon to drink; we were too frightened. About 11:30 that night old Julius Tosches…came in. He was excited. He told us that he was running down the street, away from the fire, when Saint Anthony came to him. He was in a black robe and [the saint] told him not to be afraid…that the fire would not burn Little Italy. Later we went to church and prayed to Saint Anthony. The fire stopped."

Multiple accounts of this story vary in detail, yet the common fact threaded through each tale is the happy ending of the wind miraculously shifting and taking the fire with it. Little Italy was spared! And the Italians fully believed that Saint Anthony directly and divinely intervened. "They got so excited," said Ida Cippolini Esposito in her 1979 BNHP interview, "they came back, and the wine—they loved their wine in those days—and they had the great big celebration out in the street; they were dancing. Everybody was crying. They were so happy…that it didn't hit Little Italy."

The 1946 *Baltimore Sun* noted, "While the embers of the $150,000,000 fire still smoldered, Genardo Fullano and Antonio Iannareillo founded the Saint Anthony Society. The first fete in honor of their patron saint was held on June 13, 1904…*Festa in Onore di San Antonio di Padova*…with religious ceremonies, a procession and a carnival. There were bands, flags and religious banners…many of the people cried."

The "grand marshal" of the parade, of course, was Saint Anthony, in statue form and bedecked in ribbon. As he passed by, grateful parishioners pinned money onto the ribbons. During today's festival, held each June, that tradition continues.

Previous decades of the fête included a great carnival that lasted for several days, with food booths and lights, flags and bunting decorating the neighborhood. Dancing and music took place in the streets. Local politicians and presidents of various Italian societies spoke at the ceremonial portion that included a Mass.

Two of the biggest celebrations were held in 1928 and 1931. Besides a lull in hosting this festival during World War II and the 1968 riots (it revived in 1975), Saint Leo's Feast of Saint Anthony is still a fantastically popular June event in Baltimore's Italian community. Once again, the dozens of dedicated volunteer parishioners make it happen.

## FEAST OF SAINT GABRIEL ITALIAN FESTIVAL

*It is a day that expresses best what Little Italy is really about. It is a tribute to life, one that is not as simple, plain, or as uncomplicated as it may appear to the casual observer. There are deep feelings here, honored traditions, and beautiful sentiments that spring from the ancient Italian soil and soul, the kind of feelings that express, despite the sorrows and few tragedies, a firm belief in the common good.*

*—Tony DeSales*

When the Saint Gabriel Society was established in 1928, its members had ordered a replica of the original Gabriel statue from his shrine in Italy to carry in the first street procession. In the 1920s and 1930s, festivals were held over the course of three to ten days and attracted attendees from up and down the East Coast. Vendors sold everything from nuts to olive oil, including cakes, beans, candy and Italian food. Prominent politicians from around Maryland joined the celebration and gave inspiring speeches.

Typically, residents adorned the exterior of their homes with Italian flags, banners, bunting, streamers and colored lights. Frank D'Amato of Fawn Street was known to create a special display on his house each year—a bow of lights surrounding a lantern bearing a photo of the saint on stained glass.

In his consistent theme of doom for Little Italy, author Gilbert Sandler in a 1970 *Baltimore Sun* story commented on the dwindling attendance of the participation in the Saint Gabriel procession and questioned its ability to continue. Although no longer boasting thousands of spectators, the procession persists today after the 9:30 a.m. Mass on festival weekends in August. The Knights of Columbus color guard leads the way, carrying American, Italian and Maryland flags, followed by the saint's statue, Saint Leo's clergy, altar servers bearing the crucifix and young parishioners dressed as angels. Next in line are a marching band, dignitaries and members of several parish societies.

Parishioners dressed in brown monk robes (to imitate the saint) escort the statue. Some have done so for more than fifty-five years in both festivals: John Petti, Sal Petti, Anthony Azzaro, Gabriel Mingione, Len Butta and the late Paul Lioi. Bob Zelkoski has been a cross bearer and flag carrier on and off for fifteen years.

The scene is identical for the Saint Anthony Festival procession in June. In earlier days, when it was called *San Antonio di Padova*, more than one thousand people took part. A 1932 *Baltimore Sun* story describes residents scrubbing their steps with sand, soap and water before festival time. Each house was

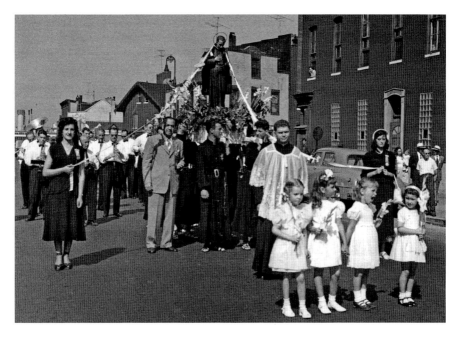

Feast of Saint Gabriel procession—a timeless tradition at Saint Leo's. *Photo by Thomas C. Scilipoti.*

cleaned spotless inside as well. "Long strips of incandescent bulbs swing gently from tall poles" for the weeklong feast that included a carnival, bands playing Italian melodies and dancing in the street. "People who are ill and almost crippled have marched in the parade as a special devotion, with the hope of being miraculously cured."

Some, like Mark Cavaliere and Rosanna Monaldi Biscotti, remember the twenty-foot "greased wooden pole that the guys would try to climb" in a contest, said Mark. "At the top was a treasure of wine and other goodies." A whole *proscuitto*, a gallon of *Chianti* and cash, to be exact, tied to cross pieces at the top. The pole was erected in the lot next to Saint Leo's School and left in place year to year. "The guys would work for hours," said Rosanna. "My brothers, Lindo and Mario, were always there. 'Killer' [Larry Marino] was the great iconic man who was front and center and instrumental to making this event possible…it was so amazing to watch."

Anthony Ferrari remembered that "the lights were awesome." Sadly, they have since been tossed; a lone "S" and a "G" remain in possession and are hung and lit up on the façade of the church during the continuing Saint Gabriel festivals.

*La Festa di San Gabriele*, September 3, 1946. The "S" and "G" lights are what remain of the festival lights and are hung on the church during the Feast of Saint Gabriel Italian Festival in August. *Courtesy Saint Leo's Church.*

According to longtime resident Giovanna Blattermann, a native of Italy, "The weeklong festivals ended in the late '60s, I believe, possibly early '70s. It was a most exciting time. It was actually two weekends. After the festival shut down in the hot summer nights, we would stay up late with our families and bring out skateboards and bikes and ride through the empty streets… all the neighbors would sit on their steps until two o'clock in the morning."

Frank "Fookey" DiAngelo remembered the same scene during the '50s festivals. "The highlight of the festival week was when the schoolboys made skate boxes," he said. "We would attach a pair of roller skates to a wooden fruit box, paint it, and we were on our way. Nothing like fifteen to twenty kids rumbling down the streets on their skate boxes for a week solid. The feasts of Saint Anthony and Saint Gabriel were actually carnivals that lasted a full week each. We had carnival-like streetlights, a Ferris wheel, wrestling matches and…fried dough was only ten cents in the church hall."

# REVEREND ORESTE PANDOLA LEARNING CENTER

*It's a nurturing environment, a sense of community. Many of our students take Italian to honor grandparents and parents who came to the U.S. from Italy. Our mission is to continue the tradition of the Italian culture.*

*—Rosalie Ranieri*

Second-generation Italian American Frank Verde, eighty, studies the language of his Italian ancestors as a practical skill for the times he visits his great-grandfather's village in San Donato val di Comino, Italy. He had first registered for classes in Little Italy at the Reverend Oreste Pandola Adult Learning Center in 2004. "I'm paying homage to my mother and her nine siblings who attended Saint Leo's School, which my grandfather built," said Verde of the former parochial school that houses the center, "for the bold step they took to leave everything behind and follow their dream to the land of opportunity and freedom."

But why didn't the younger Frank learn Italian at home? As a child, Frank (born Frank Pellegrini Verdecchia) was ashamed of his Italian heritage. "Italians were the same as the Nazis during World War II—the enemy," he said. "We had to prove that we were Americans by denying our heritage."

Yearning to better blend into American culture (especially amid discrimination, as Italians were the poorest of immigrants), many attempted to master English and wanted their children to do the same so the family would be more socially accepted.

"The Italian language was frowned upon," said Rosalie Ranieri, principal of Pandola. "It wasn't in vogue to speak Italian in the '40s and '50s—it was spoken only at home. Children were urged to go out and learn English, then bring it home to teach the parents." That was the beginning of the end of Italian spoken fluently in America's Italian families and communities like Little Italy.

Yet there are those who refuse to allow the language to die. Such was the case in 1996 of the learning center's founder. During a parish festival when he was pastor, Father Pandola had approached Ranieri with the idea to establish a cultural learning center as an arm of Saint Leo's Church. Its mission would be to continue the traditions of the Italian culture by offering classes on language, food, drink, bocce and even Italian card games. "Father Pandola's philosophy was to meet the needs of the community," said Rosalie, a Saint Leo parishioner and officer of the Little Italy Lodge.

The center began with fifty students in two levels of Italian and several cultural courses. Today, it offers seven levels of the language presented by certified and

Italian immigrant parents passed along many traditions to their children, such as baking, cooking, games and folklore, but surprisingly, not always the Italian language. *Courtesy Denise Giacomelli Loehr.*

native Italian instructors; twenty-nine teachers are on staff. Each fall and spring semester, an average of two hundred students register for various classes. The center helps people like Frank connect with their Italian heritage.

"We are blessed with outstanding teachers," said Rosalie. "We give students the opportunity to learn the language they ought to have been taught by parents and grandparents and to make items they remember making as children," such as wine, sausage, mozzarella, sauces, ravioli, Italian cookies and limoncello.

Arthur Gentile, who lives a few doors east of the school in the house where he grew up, enjoys making various flavors of limoncello. "I took it a step further," he said after learning from Sal Ranieri and Charlie Ferraro at the center how to make the liqueur's original lemon and cream versions. He has experimented with flavors such as orange, pear, peach, blueberry, strawberry, banana, cherry and spearmint. The grandson of a Sicilian immigrant, Gentile's parents owned the legendary Jake's (see the section "Business Blurbs") in their home at the corner of Stiles and Exeter Streets.

In addition to the levels of Italian for adults, Pandola also offers "Italian for Children" classes, ages ten through twelve. The full roster of courses attracts a student base of middle age, college age, seniors and children, as well as people who want to study Italian and those planning trips to Italy.

"If you don't use it, you lose it!" said Verde, who gathers with other Italian students during the summer, while Pandola is closed, at the Little Italy home of his instructor, Mary Ebrahimpour. "It's in my blood. I can honor my family by acknowledging their dreams of wanting a better life. We are now living it for them."

*For more, visit pandola.baltimore.md.us.*

## Recipe for Limoncello

*I brought this liqueur recipe from Italy about twenty years ago. In Italy, lemon leaves are also used; they cannot be waxed and are a bit more difficult to find here.*

*—Rosalinda Mannetta*

6 lemons (rinds only)
2¼ cups pure grain alcohol
2½ cups sugar
2 cups water

Remove yellow rind of lemon. Avoid the pith (white part). Place peels in glass container with lid. Cover with alcohol. Seal and cover with a cloth. Put in a dark place (where it won't be moved) for seven days. On the seventh day, slowly melt sugar with water (simple syrup) over heat. Slowly pour the simple syrup into the lemon peel/alcohol mixture. Remove lemon peels. Mix.

## Chapter 3

# *Tough Times*

## BOOTLEGGING DURING PROHIBITION

*It was all produced in nice and clean (?) tubs back in those little houses in Slemmer's Alley.*

*—Angelo Pente*

During the Prohibition Act's enforcement (1919–33) in the United States, the manufacture, sale and transportation of alcohol was unlawful. (Interestingly, it actually wasn't against the law to *consume* alcohol.) The nation's "Noble Experiment" aimed to improve character, strengthen families and lower crime rate, yet the act delivered the opposite results.

Although a federal law, Maryland was the only state to refuse the enforcement of Prohibition; this also did not stop the Italians, or anyone else who enjoyed their favorite wine and spirits, from taking the edge off after working themselves to the bone.

In a 1979 BNHP interview, Frank Pagliara (born in 1926) described bootlegging in Little Italy during Prohibition. "That's how Little Italy got its bad image," he said. "Sicilians and Neapolitans competed for the trade." Little Italy was regarded as a bad neighborhood at the time, although the bootleggers were outsiders and did not integrate into the neighborhood's daily life.

Some residents, like Joe Pizza, supplied the bootleggers. It was an era when many people produced homemade wine, whiskey and beer in their

basements, sometimes to offset job layoffs as the American economy teetered. Folks commonly drank homemade wine disguised in coffee cups.

Salvatore Pagliara, Frank's grandfather, had a still and worked it with Luigi Gatto. As a kid, Frank accompanied his uncle to the nearby ships to buy cognac to sell to neighbors. "The police were paid off—if not with money then food," he said. Small businesses that popped up around the neighborhood were fronts for selling liquor. If caught, a bootlegger was forced to pay a fine and serve sixty- to ninety-day sentences. "People were constantly in and out of jail. There were good profits to be made in bootlegging."

In the BNHP interviews, several interviewees recalled the days of Prohibition; they were just kids, and yet who was more impressionable? Joseph Bruni (born in 1915) remembered bootleggers on Granby Street, High Street and Dukers Alley and also recalled that some made whiskey for the New York and D.C. markets. Michael DiCicco thought that "prohibition inspired more drinking parties" and remembered bootleg action on the corner of Trinity and High Streets at a pleasure club.

Perhaps a more vivid and thrilling account during the interviews came from Larry Marino of 211 South High Street, who said, "As kids, the one thing we were afraid of was the bootleggers when they start shooting. We had to duck or else you had a bullet." They frequently began arguments on the street that escalated into fights, as the bootleggers accused one another of stealing customers. "We got out on the corner and played, and first thing you know, one bootlegger's hollering at another bootlegger and…they start shooting and you start running…and hide. One guy got killed…shot up on the corner there. Bingo! He laid down. Then another time…one guy got cut up, another knifed."

In Angelo Pente's unpublished memoir, he described the bootlegging scene in the neighborhood during the Prohibition era:

*These were relatively new people (aliens) who had remained after "jumping ship" and who had found shelter with relatives or friends. Not speaking the language and in need to earn a living, they turned to illicit liquor making. Some produced whiskey or alcohol from their copper stills; others merely mixed extracts with alcohol and water—their specialty usually was cognac. This group became adept in the art of fancy bottling even to the use of the fake government stamp. It was all produced in nice and clean (?) tubs back in those little houses in Slemmer's Alley. [Wearing] seafaring sweaters with collars up to their necks, they would push several bottles under their belt, board a trolley and head for wealthier sections. There, surreptitiously*

*showing their wares, having approached an unknown home, produced the cognac "right off the ship."*

*One amusing incident I recall happened late one night when a handyman (plumber), who had been entrusted to make a still, found that when, at the appointed hour it was to be delivered (usually about 11 p.m. when the police changed shifts), the still would not pass through the doorway. Very "quietly" so it seems, for no one heard a thing, with plenty of hammering and chiseling, the doorframe was removed and the still passed through.*

*A garage, now the Casa di Pasta plant [Albemarle Street], was another loading point for bootleggers. The five-gallon tins would be passed into the garage from a home in back, the trucks loaded…usually their destination was Washington, D.C.*

The term "speakeasy" defined a place to buy alcohol and was common during this era, as were raids inside them by federal agents who, according to Marino, "used to knock them off left and right here. Oh yes." The house at Fawn and Albemarle Streets, which later became the D'Alesandro family home, "was the biggest raid they had. That was a big place. It was run by Pizzas," said Marino. "The guys gave the Federal agents flat tires…turned cars over."

In the basements of some neighborhood houses were "pleasure clubs" where people could dance, such as the Rosebowl and the Trocadero; admission was about a nickel. For the rich and famous passing through Baltimore, the Fioretta Club, operated by John Butta in the 300 block of South High Street, was a large part of Baltimore nightlife in the 1920s.

"All the actors would come down there," said Ida Cippolini Esposito as she described the days of the speakeasy in her 1979 interview. "We saw Leo Currelo, the first actor I saw as a child…he was an Italian swashbuckling guy—with one of these wide hats—in those days the men wore wide brimmed hats and the long camel hair coats. I remember most of the actors walking down Albemarle Street…gosh, name them and they were all down in Little Italy…Buddy Rogers, Mary Pickford, all of them, Nancy Kelly, oh there's so many of them."

Ida's mother woke her one night to whisper in her ear that actor John Barrymore was at the Fioretta. "Anybody who was anybody would come down," she said. "It was a nice place to go. We'd stay outside and watch them come because it was like a fashion show: women with fur coats and long gowns and little sequined hats. We had the Delmar Club, Rivera Club [next to Flag House] and…the Democratic clubs."

Speakeasies mostly disappeared after Prohibition ended in 1933 with the election of Franklin D. Roosevelt.

# At War

*I remember how happy my family was when my brother Anthony came home from the war and he was in the parade…my sisters and people dancing in the street. They hung a banner across Eastern Avenue near Albemarle Street. What a very happy day.*

—*Lucille Scardapane Jeannetta*

No one, especially the mothers in the neighborhood, wanted to see the telegram boys approaching on their bikes; that never ended well. "Oh dear God, don't let them stop here," was the silent, fervent prayer on many lips, perhaps while clutching rosaries and fearing the worst. But the bikes did stop—too many times—to deliver the unbearable news that someone had perished in the war or was wounded in action: a brother, a son, a husband, a nephew or a cousin.

"Everybody had relatives there," said Eleanor Lancelotta Apicella (born 1920) in her 1979 BNHP interview. With five of her brothers fighting in World War II, she was thankful that not all were in war zones or hurt. "My mother's faith really kept her going. She believed in divine intervention and that her faith protected them."

Four Giorgilli boys—Joe, Pat, Tony and Gus—were in the service in World War II. Imagine how much sleep their mother lost. Neighborhood boy John Pica was Little Italy's most decorated World War II veteran after he served in Italy and North Africa, with awards including the Roll of Honor Award, Silver Star, Bronze Star (two clusters), three Purple Hearts and the Combat Infantry Badge.

The war undoubtedly altered the neighborhood; heavy-hearted grief was inflicted on the community. Neighbors helped to uplift the anguish of the families who lost their soldiers. A novena to the Blessed Mother was held on Monday nights, and nightly Masses were offered with prayers for protection. A bulletin board at Lancelotta's "Rhode Island" corner store held war news and postcards from abroad. The parish bulletin published addresses of the soldiers so parishioners could write to them; in turn, the grateful soldiers replied, indicating that they enjoyed hearing news from home.

Veterans Parade on the occasion of the dedication of a World War II plaque that was hung on an exterior church wall. *Courtesy Saint Leo's Church.*

On Saint Leo's exterior wall at Stiles and Exeter Streets, the parish forever remembers and honors the brave men and women of the neighborhood who answered the nation's call to defend America while serving in World War I and World War II; in Korea and Vietnam; and in the Gulf War. Other memorial plaques with special messages and photos are hung on the corner as well in memory of deceased family members.

A plaque dedicated there on Thanksgiving Day by Father Riedl in 1920 reads, "Erected by the members of the congregation in honor of these men of the parish who proved their loyalty to God and country during the Great World War. Rev. Jos. M. Riedl, P.S.M., pastor."

The war in reference is World War I (1914–18); the Honor Roll denotes seventy-nine names, with the following indicated as killed in action:

*Pietro Ambrosetti*
*Angelo Ambrosetti*
*Giacomo de Angelo*
*Henry Bacigalupo*
*Vittorio Virella*
*Joseph Zulich*

A second, larger plaque is inscribed with more than 450 soldiers' names, an Honor Roll of most of the parishioners who had served in World War II

65

(1941–45) in the various military forces. Under the names, it reads the pastor and mayor of the time: "Rev. A. Caso, P.S.M., Ph.D. and Hon. Thomas D'Alesandro, Jr." For the occasion of the plaque's dedication, the neighborhood held a Veterans Parade. Asterisks next to some of the names denote killed in action:

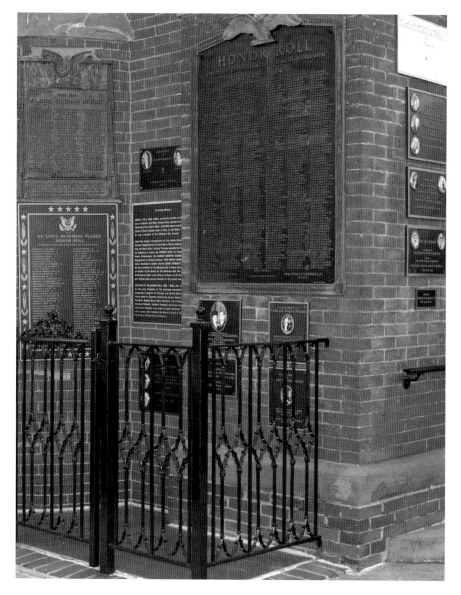

World War I and II memorial and familial honorary plaques are displayed on the exterior corner wall of Saint Leo's Church. *Photo by Thomas C. Scilipoti.*

*Frank J. Cataneo*
*Albert Concordia*
*John B. D'Alesandro*
*George Del Grosso*
*Ernest N. Ferrari*
*John A. Giordano*
*Peter Marchiano*
*David Morisi*
*Donato Pellegrini*
*William J. Pompa*
*George M. Romaniello*
*Joseph L. Tirocchi*
*Gregory S. Vaccarino*

When President Harry Truman announced that Japan had surrendered unconditionally to the Allies, thus ending World War II, an impromptu celebration broke out in downtown Baltimore, including in the streets of Little Italy. Quickly referred to as V-J Day ("Victory Over Japan Day"), the incident is still acknowledged across America. It was most notably depicted in the popular *LIFE* magazine photo of the soldier planting a kiss on the lips of a nurse in the middle of Times Square in New York City.

In the neighborhood, kissing, hugging, eating and drinking commenced as people dragged tables and chairs outside and loaded them with food. Restaurant owners served drinks and food on the house. Music began and dancing followed. Crude representations of "Tojo and Hirohito were hung, trampled and otherwise battered," reported an August 19, 1945 *Baltimore Sun* story. Resident Attilio Allori

"Uncle Sam" leads "Tojo" (portrayed by Attilio Allori and Private Casper Lozzia, respectively) in a parade after the proclamation of Japan's surrender, August 19, 1945. *Courtesy Stephanie Allori Hillis.*

dressed in an Uncle Sam costume and rode a white horse in an impromptu parade. Baltimoreans were "almost delirious with joy."

The following description was included in the 1881–1981 Saint Leo's anniversary book, taken from a September 1945 parish bulletin:

*When word of Japan's surrender reached Little Italy, the Saint Leo's Band was holding its weekly practice in the school hall. Wild with joy, the band members poured out into the street and struck up an impromptu parade...*

*Sun Square [downtown Baltimore] had nothing over Little Italy in celebrating V-J Day. Headed by Saint Leo's Fife and Drum Corps, a long parade accompanied by the tooting of the horns of some fifty cars filled to capacity with men, women and children cheering, shouting and singing went through every street of our neighborhood. Flags and bunting beautifully decorated every block in a celebration that started Sunday when a premature flash set the people wild until the official announcement was made on Tuesday evening...no doubt ours was the first parade of Baltimore.*

*Little Italy was bedlam. The church bell started to ring, and the shriek of steam whistles from the shipyards further added to the din...hundreds of people, many of them from other sections of the city, visited [Saint Leo's] and prayers and tears flowed abundantly...hundreds of vigil lights adorned the Shrine of Our Lady of the Miraculous Medal where our people had made continuous Novenas for the safety of their dear ones and for peace.*

Twenty-seven years earlier, the same excitement and craze had overtaken the streets of Little Italy when the Armistice (end-of-war agreement) was signed in 1918.

# VISITING ITALIAN POWS

*That was the best part of my life. We were treated like kings there, but what I didn't do for them [POWs]. What I treasure most is a big plaque they gave me with the words: "We will never forget what you did for us."*
—Guy Sardella

During World War II (1941–45), the U.S. Army had captured and shipped to the states almost 500,000 Italian, German and Japanese prisoners of war and housed them in 650 camps across the forty-eight states.

Camp Meade (now Fort Meade) in Maryland, located between D.C. and Baltimore, was both a training center and headquarters for the Enemy Prisoner of War Information Bureau; it first hosted POWs in September 1943—1,632 Italians and 58 Germans—and kept records on all POWs throughout the United States.

The POWs worked locally, building stone bridges on post and laboring on area farms. Because Italy had surrendered to the Allies, the Italian POWs were given privileges and treated better than the Germans, such as being allowed to shop in the post exchange and being allowed to leave the compound with visitors.

"We were treated better than we were as soldiers in the Italian army," said Lelio Tomasina in a 1993 *Baltimore Sun* story, "as if we were family." He arrived on a ship at age twenty-two, bent down and kissed the American ground. "It was so unbelievably magnificent. I was sure the Americans were just being nice before they shot everybody."

As a boy, Johnny Manna remembered visiting the Italian soldiers with his family. Some were from the same villages in Italy as the Baltimoreans. It made quite an impression on the then eight-year-old: "First thing I'd see

On Sundays, special privileges for Italian prisoners allowed Baltimore's Italian community to visit the POWs at Camp Meade, Maryland. *Courtesy Johnny Manna.*

when we were close to the compound," he said, "was the American soldiers in guard towers with automatic weapons, barbed wire fences and the big red 'PW' lettering stamped on the backs of the POW fatigues."

His family—parents Mary and Pasqual "Patsy" Manna, grandmother Consiglia Tana, aunt Jean Tana and uncle Luigi and aunt Aninna Molino—had prepared picnic food for the soldiers. They cooked meals the prisoners were accustomed to eating at home: veal cutlets, roasted chicken and peppers, macaroni, potatoes, salads, greens, cakes and homemade wine.

"We visited on Sundays," said Johnny. "My family knew some of the prisoners." He recalled some of the other Little Italy families who visited Camp Meade: Altieri, D'Adamo, Ippolito, Fabi, LaCanale, Lamberti, Muratore, Montefarante, Suriani and Campanoli.

It was not just Little Italy residents who interacted with the POWs; so, too, did others in Baltimore's Italian community. The late Olga and John Bianchi entertained small groups of Italian POWs in their home on Baltimore Avenue in Dundalk. "They appreciated being invited into our homes," said Mike Pirisino, brother of John Bianchi.

After learning of the POWs' privileges, WCBM radioman Guy Sardella, a native of Little Italy, prompted folks on air to visit them. Soon after, lines of

Baltimore's Italian community often brought picnic food to the Italian POWs at Camp Meade, Maryland—cuisine they were accustomed to eating in Italy. *Courtesy Johnny Manna.*

cars containing hundreds of people motored weekly to Camp Meade, laden with picnic food, cheerfulness and the prisoners' native language.

Sardella became a liaison. He organized a musical band among the prisoners, introduced them to local Italians, arranged for Catholic Masses at the outdoor chapel, organized a soccer team and took Baltimore mayor Thomas D'Alesandro to the barracks to deliver a speech in Italian. "He fielded angry letters from local men who complained that their wives were spending every Sunday afternoon socializing with POWs," wrote Rafael Alvarez in a 1993 *Baltimore Sun* story.

Little Italy resident Rosalia Scalia remembered Tomasina "talking about how he came here as a prisoner of war; how he thought he had died and went to heaven because he had never seen so many eggs, grapefruits and oranges in one pile at the camp."

Tomasina, similar to about thirty other POWs, married a girl from Little Italy—Sue Gentile—and became an American citizen. As did Bruno Brotto from Padua, who married Gabriella Fabi in 1946; her father, Jimmy Fabi, owned a barbershop on Eden and Gough Streets. POW Rolando Giacomelli from Prato, in the Florence region, married resident Anna Giro six months after they had met at a dance hosted by the Italian community for the soldiers. They moved into a house on Gough Street, two doors down from her parents, Rosa Meo from Riposto, Sicily, and Nicola Giro from Vasto.

Francis Tarasco, born in 1912 in Vicocanavese, Italy, married American-born Elsa Impaciatore. He said in his 1979 BNHP interview that he came to the United States on the *Queen Mary* as a prisoner after being captured in 1944. He had joined the army in Italy because "it was compulsory for all men to serve under Mussolini. At first, men in the U.S. Army spoke to us in Italian to persuade us that the American way was best. They made propaganda and told us the news was bad, that Italy was 'coming apart.'"

By day, he worked at Camp Meade, keeping inventory in the army's store. At night, he worked at the Federal Bureau of Investigation (FBI) in Washington, D.C., "to do nonstrategic work on mail that U.S. soldiers sent," he said. "The Italian community in Baltimore entertained and visited us, and asked for news of relatives."

It was a memorable time, yet all Camp Meade prisoners were gone by the fall of 1944. Laid to rest in its cemetery, marked with simple white headstones, are thirty-three German POWs and two Italians: Agostine Maffeis and Pasquino Savigini.

## Chapter 4

# Notable Buildings

## STAR-SPANGLED BANNER FLAG HOUSE (1793)

*National Historic Landmark, U.S. Department of the Interior, National Park Service*

> *The Star-Spangled Banner is a symbol of American history that ranks with the Statue of Liberty and the Charters of Freedom.*
> *—Smithsonian.com*

Pratt Street could have remained Queen Street, as it was once named, considering the enduring royal treatment of one of its residents. Mary Young Pickersgill, who earned her mark in history as the maker of the original Star-Spangled Banner, once owned what is now the Star-Spangled Banner Flag House at 844 Pratt Street in Little Italy. She was commissioned to sew the flag that flew throughout the night at Fort McHenry during the Battle of Baltimore (September 1814) in the War of 1812 (which ended in 1815); it was in that house where she began the flag that inspired Francis Scott Key to write what would become our country's national anthem.

The Flag House is one of the oldest houses in Baltimore. Built in 1793 by landholder Brian Philpot around the same time the star-shaped Fort McHenry was built, the house was designed in "a fashionable section of the young city," noted a 1957 *Baltimore Sun* story, "close to Front Street where were tied up the great Baltimore schooners…bringing back treasures of the Orient which merchants and sea captains proudly used in their homes."

The Star-Spangled Banner Flag House decked out in bunting for the 1914 Star-Spangled Banner Centennial celebration. *Courtesy Flag House.*

Maintained as a historic house museum and exhibition space since 1927, one of its permanent exhibits depicts the career and life of Pickersgill. On display is the original receipt for two flags: $405.90 paid to Mary, her mother and daughter for the large banner, which they sewed in six weeks, and $168.54 paid for a smaller seventeen- by twenty-five-foot storm flag. Both were ordered by the commander of Fort McHenry, Major George Armistead, who desired a flag "so large that the British will have no difficulty in seeing it from a distance."

To meet their deadline, the three women labored ten hours a day to complete the fifteen-starred, fifteen-striped garrison flag (representing the then fifteen states) out of some three hundred yards of English bunting. The piece was so big—thirty-foot hoist by forty-two-foot fly—that it was necessary to assemble it on the floor of the nearby Brown's Brewery (later Clagett's).

Naturally, 844 Pratt Street has undergone additions and renovations over time, including a shop window added to the front (later removed and replaced with a door and windows) and Pickersgill herself adding a kitchen to the first-floor rear and a boarder's room upstairs. A dependency building was built in 1953 behind the main house, and mementos of the War of 1812 were moved into it.

Neighboring houses were demolished in 1950 to create a spacious lawn to the left. The former row house now stands alone; its original entrance was reopened on Albemarle Street. It is furnished with numerous period pieces and possessions of the Young-Pickersgill family, including Mary's 1740 mahogany desk.

The flag theme, for which the small house is most notoriously known, varies greatly from what the house was used for afterward. Pickersgill (1776–1857) and her mother, Rebecca Flower Young, both employed as ship and military colormakers, lived and worked there. After renting it for thirteen years, they purchased it in 1820; it remained in the family until 1864.

The structure later took on a variety of uses: saloon, cobbler shop, general store, post office, steamship ticket office, warehouse and a home to an Italian who made fine-tooth combs. It physically bridged the communities of Little Italy and Jones Town. Families of other ethnic groups, such as Jews and Lithuanians, once rented the second floor (in 1898 paying six dollars per month).

The *Dispensario Medico Chirurgico* (Surgical Medical Dispensary) once occupied the building, run by a pharmacist named Dr. Giampiero. Placido Milio in 1905 had become his assistant and eventually took possession of the house, where he lived conducting myriad services until 1927: an Italian shipping line serving the community of Little Italy with Italian-speaking agents, *Banco di Napoli* representative, expediter for Adams Express Agency and telegraph and postal service. (Milio, a name that still exists in Little Italy today, and a few dozen of his friends, founded the Maryland Order Sons of Italy in 1913. Its first lodge was named the Guglielmo Marconi Lodge. Their goal was to unite Italians in one large organization to preserve the Italian heritage and uphold culture and traditions. The Little Italy Lodge today, a Sons of Italy chapter, carries on the group's mission.)

After the War of 1812, the original American flag sewn by Pickersgill was kept in the care of Commander Armistead's family. In 1912, it was loaned permanently to the Smithsonian's National Museum of American History in Washington, D.C.

In 1975, the Star-Spangled Banner Flag House was named a National Historic Landmark. Today, the Flag House in Little Italy thrives as an interactive experience for school groups, Scout troops and Baltimore tourists interested in learning one of the most important stories of our nation's history, "a place where inspiration was sewn, and history comes alive."

To honor this important part of its history, the City of Baltimore announced its new slogan in January 2015: "Baltimore: Birthplace of 'The Star-Spangled Banner.'"

*For more, visit flaghouse.org.*

# PRESIDENT STREET STATION (1849)

*They got off and didn't know they weren't where they were supposed to be; they were going for the gold.*

*—Elia Mannetta*

*National Register of Historic Places*

The President Street Station, one of the oldest big city railroad stations in the nation, played an essential role in the story of Italian immigrants as they arrived in New York City and (some) continued to Baltimore.

Its two-story brick construction cost $8,812 and was designed by architect George A. Parker of the Philadelphia, Wilmington & Baltimore Railroad (PW&B; today Amtrak). Parker designed the station in Greek Revival/Italianate style with low-relief columns and a Roman curved arch roof. The station immediately was used as one of the emigrant railroad gateways.

President Street Station was completed in 1850, an era when New York City was jam-packed with European immigrants arriving daily on steamships by the hundreds. Groups naturally began to spread out into the states. By railway, they predominantly traveled to New Jersey, Philadelphia and Baltimore, and other points south and west, as they sought opportunities to settle, work and reconnect with family members who had previously emigrated.

Since the U.S. government had an interest in populating the West after the Indians were pushed out of the frontier, it helped to subsidize the railroad; in turn, the railroad subsidized the ships arriving from Europe. The destitute immigrants forced to use subsidized travel were not allowed to remain in New York City. They were instructed to clear immigration and immediately use the emigrant railroad to travel west to points such as Minnesota, Nebraska and Kansas. Obviously, many violated the command.

"President Street Station is really your Ellis Island," said local historian and researcher Robert Reyes, vice-president of the Baltimore Civil War Museum currently housed in the station in the southwest corner of Little Italy. "Immigrants continued to arrive in Baltimore to flock with their kind. They set up pretty much right where they got off the train"—a good explanation for why today's Little Italy restaurants are in houses. When some couldn't find work because of discrimination and economical conditions, homeowners took on boarders, and this naturally required cooking for them. In the long run, some of those boardinghouses evolved into restaurants.

The 1850 President Street Station/Pennsylvania Railroad facing Old President Street (at Fleet). The upper front façade shows the original decorative brackets below the overhang arch. *Courtesy Friends of President Street Station.*

What remains of the 1849 head house of President Street Station is diminutive compared to the size of it when a 208-foot train shed was once attached to its back. Tracks along Pratt Street connected the station with the Baltimore & Ohio (B&O) Camden Station (circa 1850s, now home to Major League Baseball's Oriole Park at Camden Yards). Horses once dragged train cars between the two stations.

A decade later, in 1861, on the way to his inauguration in Washington, D.C., Abraham Lincoln traveled secretly by train across Baltimore. Why on the sly? Protection. Presidential elections sometimes caused fatal riots. A detective had received word that Southern radicals had intended to assassinate the president-elect in Baltimore, known then as a violent city and referred to as "Mobtown." (The President Street Station has the distinction of being the site of the first causalities of the Civil War when Union soldiers fired on an angry mob of Southern sympathizers.)

When heavy snowfall collapsed the train shed in 1899, an elongated pitched roof shed was built from it and east to Central Avenue along Fleet

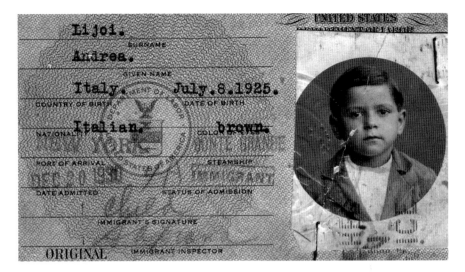

"1930 Green card issued to me at Ellis Island, evidence that I had been admitted legally into the United States as a permanent resident. My mother, Rosaria, my ten-year-old sister, Catherine, and I landed in New York on December 20, 1930 aboard the *Conte Grande*. My father, Bruno, had been in the U.S. before World War I, returned to Italy to fight against the Austrians, and then came back in 1920." *Courtesy Andrew Lioi.*

Street. The replacement was completed in 1913. Inside were railcars, boxcars and other mechanisms needed for freight operation, as well as a passenger terminal and waiting platform. It was destroyed by fire in 1978; the ruins were cleared and the station abandoned.

At the time, rail tracks that ended at the waterfront on President Street were owned by three short line railroad companies that merged in 1838 to become the PW&B Railroad. Taking control in 1881 was its successor, the Pennsylvania Railroad, which eventually handled freight only and transferred most passenger services from the President Street Station (around 1910) to the new Union Station (today Penn Station) on North Charles Street.

When another collapse of the original head house in 1990 put its condition in peril, those who cared about losing this significant historic station dedicated themselves to its reconstruction. "The President Street Station is an American treasure," said Senator Ben Cardin in 2013. Along with Senator Barbara Mikulski, Cardin had reintroduced legislation to help ensure the future of the station. "Volunteers have worked hard to keep the station's history alive." That history includes roles the station played during the Civil War, Underground Railroad and the growth of Baltimore's railroad industry.

The Baltimore Civil War Museum opened in 1997 and is operated by the nonprofit organization Friends of President Street Station (established

1987), which has worked hard to save the station. It is responsible for getting it listed in 1992 on the National Register of Historic Places; also, the group provides programming, staffing and marketing for the museum.

*The Civil War Museum is open to the public Thursdays through Mondays (10:00 a.m.–4:00 p.m.) with free admission. Visit baltimorecivilwarmuseum.com or call 443-220-0290.*

# TACK FACTORY (1858)

*It's the greatest place in the world to work.*

*—Frances Votta*

How refreshing when a Baltimore historical building is refurbished instead of demolished—an act of respect toward our city's history. Reusing exposed brick, original flooring or cast-iron columns as part of a new design lends to a building's existing character and antique aura. The renovation of a noteworthy landmark keeps history locked within its walls rather than pretending it never existed and the casual observer never learning its story.

The building on the corner of 1300 Bank Street and Central Avenue, better known as the Tack Factory, is such a structure and has retained some of its historical characteristics. It shows up on records in 1858, believed first to be built as a school in the middle of the Civil War, but it was needed in 1863 as the Union Relief Association, a resting place for wounded Confederate soldiers and prisoners to be fed and housed before being moved to Philadelphia hospitals by railroad.

Thick wooden beams lined the interior, and heavy steel bars on the windows were added in 1861 to keep in the prisoners. "We left them on through the years to keep anyone else out," said Dick Holland, eighty-one, grandson and great-nephew of the Holland brothers, who were founders of the Tack Factory, formally named the Holland Manufacturing Company.

After the war, when the area turned industrial, Monroe and Franklin Holland relocated to Baltimore from New Britain, Connecticut, to run the factory, which was established in 1897. The plant manufactured brads, nails, tacks, staples and fasteners ultimately used on bulletin boards, upholstery and rugs, as well as to hold together skins of major-league baseballs during the stitching process.

The brothers employed primarily Italians, the majority of whom were residents of Little Italy—names like Biscotti, Pasqualone, Granese, Russo, Boeri, Mezzanotte, Votta and Romaniello. Theresa Pasqualone worked there for just over sixty years; she started at age sixteen and retired at age seventy-three. "Seemed that everyone in Little Italy had someone who worked at the Tack Factory," said Holland. "Tony Fica was our truck driver for over fifty years."

Under the shadow of the three-story building is Central Avenue, formerly Canal Street. Local historian Robert Reyes said that it was built over a canal (Harford Run) and is the reason the street is so wide. Today, the water runs underneath through a large brick storm drain tunnel and dumps into the harbor a few blocks south.

From within the then two-story building erupted rapid-fire noises from tack-making machines that were silenced around 2000. Some thirty turn-of-the-century Perkins tack machines did the noisy trick of spitting out common household tacks. "With their spinning flywheels and overhead belt drives, the old machines resemble a 1915 Charlie Chaplin movie set," wrote Jacques Kelly in a 1991 *Baltimore Sun* story.

The generation after Dick Holland sold the property to a developer, who in turn renovated and flipped it. Today, Kevin Hollins's company, Canal Group, owns and leases the massive space. Housed inside the now three-floored historic building are other sounds and activities: independent capitalists bustling and co-working at Capital Studios; the crash of bowling pins inside Mustang Alley's Bar & Bistro; chefs clinking pots in the kitchens of Heavy Seas Alehouse and My Thai restaurants; and *la linqua bella*, spoken by *Piedigrotta* owners Carmenantonio and Bruna Iannaccone, who operate an Italian bakery and pastry shop.

# Canal Street Malt House (1866)

*It's good to be home again!*

*—Steve Geppi*

Serving a purpose completely different than what it was designed for in 1866, the Canal Street Malt House building in 2014 houses thirty-eight residence condominiums and, in 2005, was renovated by developer Union Box Company—$20 million later.

Named after the canal that once ran down the middle of Central Avenue, the structure was long ago the Solomon's Straus Malt House, named after

the brewer who built it. The warehouse supplied malt to Baltimore's brewing industry, as well as exported it to the west and south.

Before the current gourmet kitchens, open square footage and twenty-foot ceilings were added in these New York–style lofts, machinery once turned Canadian barley into malt. It was hoisted to the top floor, cleaned of impurities, weighed, separated into tubs and stored in kilns to dry before being packed into bushel sacks.

The once seven-story building previously served as artists' studio spaces and an Atlas Food warehouse. It features red brick walls and massive glass windows outside, with exposed concrete columns and flooring inside. Developers added on to the building to make twenty-five additional lofts; thirteen exist in the original malt house. Joining the two pieces in between is a stylish interior courtyard complete with bridges, walkways and a glass-enclosed elevator. The Little Italy Garage is housed on the first level.

Several years ago, Baltimore Orioles co-owner, *Baltimore Magazine* publisher and comic book entrepreneur Steve Geppi moved into this building after returning to his roots in Little Italy. "Moving into the Canal Street Malt House was a homecoming long overdue," said Geppi. "Having spent the first 20 years of my life in Little Italy, I feel that moving back to the greatest neighborhood in the world has brought my life full circle. It's one of the best decisions I have ever made."

His neighbor is Jim Palmer, Major League Baseball's Hall of Fame pitcher, who lives on the top floor of the original structure. Palmer said that he enjoys a panoramic view to the north, south and east. "It's a very convenient location," he said. "I can walk to the restaurants in the Little Italy. It's close to the airport, the ballpark and Canton."

Central Avenue seems to end the boundary of Little Italy, but it actually doesn't. The neighborhood extends one more block east to Eden Street. The wide boulevard-type street once housed other industrial businesses, including Saval Foods Corporation and Fallsway Spring & Equipment Company. The latter building was renovated in 2013.

# Chapter 5

# *The Friendly Little Italy Lodge ( Sons of Italy)*

*To initiate and/or promote activities, events and education programs that preserve Italian culture, heritage and legacy.*
*—Mission and By-Laws of OSIA Lodge No. 2286*

Compared to the remainder of Little Italy, the site of Sons of Italy Lodge at 905 East Pratt Street is rather new. Its groundbreaking ceremony in 1990 included members ceremonially digging the first shovels of dirt from a former city basketball court. Individual contractors Guy Matricianni, Ray Moracco and Joe Campitelli swiftly built the $175,000 structure, and in January of the following year, the lodge hosted its Gala Grand Opening with a Holy Mass and celebration.

The three official founders of the Little Italy Lodge (in 1972) were Constantine "Gus" Giorgilli and father and son Alfonso and Elia Mannetta, natives of Calabria, Italy. There had been two previous attempts to form a lodge "that failed," said Giorgilli in an account written by Joe D'Adamo and posted on the lodge's website. "But in 1972, when Elia Mannetta suggested we try again, we were determined not to fail, and we didn't, thanks to the hard work of a lot of people."

Not unusual for a community like Little Italy, the first organizational meeting was held in a home—in this case, at Ida Esposito's in January 1973. By the second meeting, there were 36 members and by the third, 136. Responsible for drumming up membership and collecting the ten-dollar dues were Mike Salconi, Simon Scalia, Jerome Rifkin, the Pagliaras and

Some Little Italy Lodge members marching in a Columbus Day parade, circa 1995, with custom-made costumes representing various regions in Italy. "Fabulous volunteers and dedicated members!" said Nancy Azzaro. "We went all out in those days." *Courtesy Little Italy Lodge.*

Mike "Hokie" Popoli. Meetings thereafter took place around Little Italy, in the school, church and at the No. 2 School (now Stratford University).

"The Lodge was created to help Little Italy survive," said Elia Mannetta, its first president. "It is a muscle for the parish. One reason it came into existence was to give the community a partner, especially to fight the closing of Saint Leo's School and to take sides against the archdiocese's parish clustering program."

Determined to find a home, lodge members voted to purchase an aged, 100- by 40-foot, $10,000 beat-up barge in the water along Lancaster Street once used to teach carpentry to prisoners. Member Lou Mann and fellow lodge members refurbished the structure to make it presentable; a kitchen was added, and the walls were paneled. Fundraisers were held to raise capital, including the production and sales of a Little Italy Lodge cookbook in 1987.

Mike Girolamo, eighty-eight, a native of Vasto, recounted a previous incident around New Year's Eve when the barge was cut loose from the dock; they never found out who performed the mischief. Their New Year's Eve dance had to be canceled that year.

Nevertheless, the tired barge had lived its life and sank after developing pump failure. Although not completely submerged, the lodge was unusable. "Everything went down," said Lucy Pompa, ninety-six, a former Lodge member. "It was sad," noted Mary Apicella, a past president. "Everyone was really disappointed. All the work we put into it. It was a lovely place—unique. No one else ever had a barge as a lodge." Apicella has been involved with Sons of Italy for forty-seven years and still resides in the neighborhood.

Several summer Italian festivals were held alongside the barge, and this led the Maryland State Lodge to invite the Little Italy Lodge to host the first Italian Festival at Rash Field in 1973 at the Inner Harbor. Mayor William Donald Schaefer created a proclamation designating August 18–19, 1973, as "Italian Festival Days" in Baltimore: "Whereas, Baltimore's Italian community has made important contributions to the development of our City, with many persons of Italian descent achieving positions of great prestige." These packed Inner Harbor festivals continued for about a dozen years. Italian festivals were also held around the city in Patterson Park (circa 1994), Fifth Regiment Armory (circa 1982) and Heritage Park in Dundalk.

In appreciation of his support in 1977, Sons of Italy presented to Mayor Schaefer a thirty-six-foot authentic gondola, trimmed with brass, that had been shipped from Venice. In subsequent festivals, the vessel was displayed at the festival; it has also been used in a number of city parades, most notably the Columbus Day parade, but eventually it fell into disrepair. When a few years back the Grand Lodge of Maryland voted to dispose of the gondola, the Little Italy Lodge agreed to take ownership. It is now stored on company property of Iacoboni Site Specialists (a surname that tells the tale of Camillo Iacoboni, born 1897, who emigrated from Teramo at age sixteen).

Waterlogged from the elements, the front of the gondola is weathered but acceptable; the midsection needs to be replaced and the entire boat reconditioned, reported Anthony Montcalmo, 2011–13 lodge president. Tom Iacoboni joked, "Don't try to use it in the water."

Today's Little Italy Lodge forges ahead as brawny as ever. With close to four hundred members, it seems to host the largest number of events per year than any other nonprofit organization in Little Italy, including its popular and affordable Friday Night Dinners. A steady volunteer base and dedicated council members work jointly to host these weekly dinners, plus monthly bingo, bus trips, dances, sock hops and more. As well, the lodge participates in neighborhood events, such as selling merchandise and food during the summer Italian festivals and sponsoring a float in the annual

Columbus Day Parade. A portion of proceeds from Saint Leo's annual Feast of Saint Gabriel benefits the Little Italy Lodge.

Successful events happen because devoted people stand behind them to make them happen. Bob Taylor, lodge orator and 1993–97 president, thinks that the loyalty of the lodge's many volunteers stems from "a desire to belong to something…a dedication…self satisfaction." It is a 100 percent volunteer-run organization (barring a paid chef for the Friday Night Dinners).

Montcalmo cited "camaraderie, fellowship, good will, tradition and warmth" as reasons for the lodge's popularity. "The more there is, the more the participation and support there is."

Following Mannetta's presidency (1973–76), others who have served as lodge president (most were/are natives of Little Italy) include John Dell'Uomo, Mary Apicella, Bob Taylor, Nancy Azzaro, Joe D'Adamo Sr., Sal Ranieri, Charlie Ferraro, Frank Cossentino, Anthony Montcalmo and current president, Sal Spinnato. "The Sons of Italy has been a tradition with my family," said Spinnato, who still thinks of himself as a neighborhood boy. "It is with great pride and appreciation that I serve…an honor to follow in my father's footsteps."

The membership database lists family names that have existed in Little Italy for decades, including Apicella, Butta, Castangna, Cossentino, Esposito, Ferraro, Girolamo, Lioi, Manganello, Milio, Nucci, Pompa, Ranieri, Scalia, Vitale and countless more.

The Little Italy Lodge No. 2286 is an arm of the national Order Sons of Italy in America, which was founded in New York City in 1905—the largest and most geographically represented organization of Italian Americans in North America. "When people talk about the success of the Little Italy Lodge with its beautiful building and…members," said Giorgilli in 1988, "I hope they don't forget how it all started."

## Chapter 6

# *Pente, Pompa, Pelosi and Other Prominent People*

## TONY DESALES, LITTLE ITALY'S ARTIST

*We start here, sometimes. We finish here, all too often. Still, Little Italy's nice to come home to.*
                                                        —*Tony DeSales (1941–2000)*

It was his corner. He thought of it as his own. His easel, sketchbook and colored pencils owned it. The spot at High and Fawn Streets in front of Chiapparelli's Restaurant was where Tony DeSales stood outside—in all kinds of weather—sketching his neighborhood, animatedly conversing with tourists and neighbors and selling his drawings of Baltimore. He earned the name "Little Italy's Artist." Some thought of him as its ambassador.

It must have been a fine corner, for in the almost thirty-five years he used it (and across the block in front of the former Rocco's Capriccio), he encountered many movie stars, personalities and sports figures: Danny DeVito, Dustin Hoffman, Luciano Pavarotti and local Baltimore Orioles and Colts.

Love for his neighborhood burst from his artwork. Three years after his death in 2000, one of his four siblings, Rita DeSales French, published his illustrations in an impressive coffee table book, *Baltimore's Own Little Italy Artist: The Artwork of Tony DeSales*. It is a splendid tribute to her talented and charming brother and includes a delightful section of postcards he received

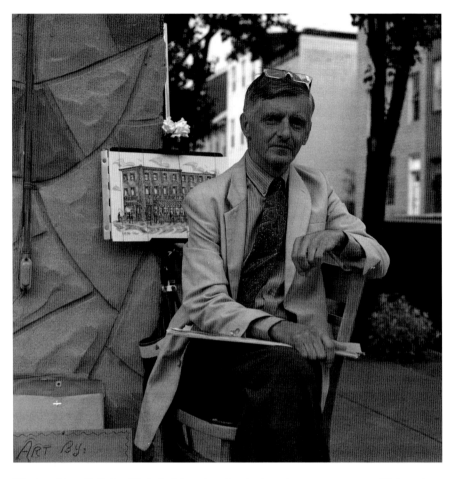

The late Tony DeSales, Little Italy's artist, sketched on the street corner at High and Fawn for thirty-five years, interacting with multitudes of tourists and celebrities. *Photo by Thomas C. Scilipoti.*

from around the world—*his* postcards, ones that he produced from his sketches and freely handed out to passersby, asking them to write to him when they returned home. His home was 236 South Exeter Street; his ancestors had lived in Little Italy since 1888.

"Once you were in his line of sight, he would not forget you," wrote Rita in her book. "You became his friend and he always remembered you. He wanted to make an impact, to keep in touch…He wanted them to love him."

Tony's exceptional knack for touching people's souls derived from other talents beyond his artwork. He was a self-taught writer, poet, musician, mentor, tutor, editor and songwriter, as well as an organist at Saint Leo's

Church. A younger Tony taught at Poly Institute for seven years. He was a one-man street show. Well, two, if you count the neatly dressed old lady in pearls sitting nearby in a folding chair—*Mamma* Genevieve, Tony's mother, whom he physically cared for since he was a young boy almost up until her death in 1998. He lived with her during his entire bachelor life. "I was born forty years old to take care of my mother," he once said.

"They spent many summers together on that corner," said Rita about "Petey," Tony's nickname, "both of them proud of Tony's accomplishments."

Adding caretaker to a long list of God-given gifts, the act didn't stop with *Mamma* Genevieve. Arm in arm, he walked senior Italian neighbors to church, ran their errands and took them shopping.

Although the artist felt most comfortable on his Little Italy corner, Tony sketched his way through other parts of Baltimore; Washington, D.C.; Philadelphia; New York City; and Annapolis. His extensive collection of drawings speaks as to exactly what he saw and transferred to paper.

When Tony set down his watercolors, he picked up a pen. He had a great deal to articulate in *Piccolo*, a newsletter he initiated in 1975 and dubbed "a small voice you have to listen to." Handwritten in Tony's meticulous and small yet tidy handwriting, the issues were photocopied by neighbor Mike "Toodie" Geppi of Geppi Press (408 South High) and sold for twenty-five cents apiece. Its content established editor Tony as opinionated, zany, warm, brash, blunt, witty, cantankerous and sometimes—if a reader noticed the tiny print along the bottom—plain rude: "If you're illiterate, kindly do not read and crumple *Piccolo* without paying a lousy quarter for it, cheapskate vandal."

The newsletter was jammed with community news, well wishes, horoscopes, matching quizzes, political ramblings, poetry and snippets of conversation heard around the neighborhood and in community meetings. An excellent and insightful writer, Tony yearned to tell it as he saw it: "[W]ho we are, where, and most oftentimes, why...all the news for Little Italy that's fit to print."

Now only hollowness stands at the corner of High and Fawn. Restaurant patrons unknowingly meander past the spot where Little Italy's artist once stood. Most will never hear his story, and if it's February 25 (the date he died), they may wonder why a bouquet of flowers is there. But Tony's neighbors know, as do his siblings who placed them there. "It gives me a sad feeling to think he should be there," said his sister Anita Nucci. "He was a permanent fixture on that corner."

# D'ALESANDRO DYNASTY

*My mother was the real politician in the family.*
*—Tommy D'Alesandro III*

Producing a son who became a mayor and a daughter who became a congresswoman seemingly would be adequate accomplishments for any one Italian immigrant family. Yet the D'Alesandro family of Little Italy was quite distinctive. The two notorious offspring (Nancy D'Alesandro Pelosi and Tommy "the Younger" D'Alesandro III), plus their four siblings, grew up under the thumb of a mayor and congressman father, Tommy D'Alesandro Jr., and a lasagna pan–brandishing Democrat activist mother who hailed straight from Italy. Annunciata Lombardi D'Alesandro, her name Americanized to "Nancy," raised a family centered on public service.

Matriarch. Overseer. Housewife. Tough. Nancy was known as Baltimore's first "hands on" first lady—quiet but forceful—after she learned more about politics than her husband and childhood sweetheart, Tommy. "I think about if she was born today, what she would have accomplished," said Pelosi in a 2013 Maryland Public Television interview. "She was so spectacular. She was brilliant. She was imaginative, hard working, a wonderful, wonderful mom."

Her father was born on President Street in 1903, lived his entire life at 245 Albemarle Street and generously served Little Italy's Saint Leo's parish and school. He won his first political office before age twenty-three.

After the couple married in 1928, Nancy managed her husband's legal office out of their home and later gave him much-heeded political advice. His long and well-known career included a 1935 election to city council, service in the state legislature, five terms in U.S. Congress, service in the U.S. House of Representatives and three terms as Baltimore's first Italian mayor (1947–59). Yet he never forgot his roots or his neighbors.

Matriarch Nancy had been full of defiance and spunk since adolescence, when she accepted a job at an auctioneer's before it was appropriate for women to work. She became a feminist before the word was in the dictionary. She formed her own political army in aprons that worked in the basement of the D'Alesandro house—dozens of neighborhood women-turned-campaigners who mailed letters, organized rallies and answered phones. She helped those who turned to the powerful D'Alesandro family for help.

"She was a very fiery woman," said the late Governor William Donald Schaefer, who openly admired her spunk and energy. "[She] loved her kids

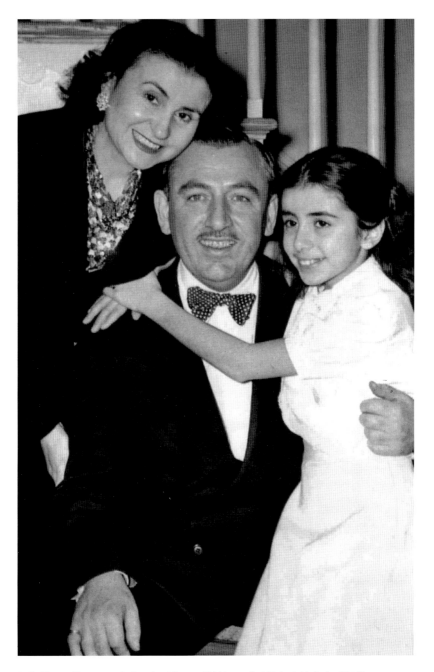

U.S. House Democratic Leader Nancy (D'Alesandro) Pelosi (right in 1951) grew up in Little Italy with her political parents, Annunciata ("Big Nancy") and two-term mayor Tommy D'Alesandro Jr. Her brother, Tommy III, also served as mayor. *Photo by Thomas C. Scilipoti.*

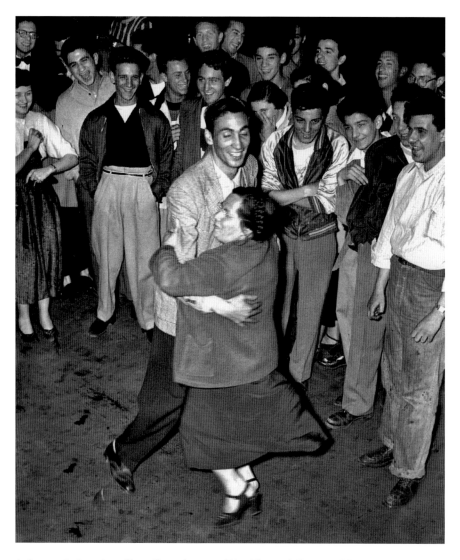

A dance of triumph on Fawn Street between John Pica and Concetta Marcantoni when Tommy D'Alesandro Jr. was voted mayor in 1951. *Photo by Thomas C. Scilipoti.*

and was superb to Old Tommy." As mayor of Baltimore, Schaefer succeeded Nancy and Tommy's son, Tommy D'Alesandro III, a prominent lawyer who served from 1967 to 1971.

Nancy lived until age eighty-six. Toughness must be hereditary because her namesake daughter, "Little Nancy," seems to possess it, too. Seems that anyone in politics needs a tough hide to survive its ridicule. It's no secret that

since being sworn into office in 1987, criticism has been thrown from all directions at California congresswoman Nancy Pelosi, Democratic Leader of the U.S. House of Representatives. But *mamma*'s moxie gets you voted as the first woman in American history to serve as Speaker of the House (2007–2011). She is Annunciata's daughter; she learned durability from the best. Big Nancy was unknowingly grooming her daughter to enter politics when, in fact, she wanted her to become a nun—a conversation that lasted for fifteen years.

It's hardly surprising that Little Nancy and Tommy "the Younger" evolved into politics. Why wouldn't they have? The D'Alesandros encouraged their children to believe in public service as a noble calling and taught them that people have a responsibility to one another.

Whether or not their parents had aspirations for them to hold political power, it surfaced by default. They lived and breathed it as children and young adults, working the front office, where political lingo and activity was nearly inescapable at D'Alesandro headquarters on Albemarle Street. "Our whole lives were politics," Pelosi said in an interview during her first Congressional race. "If you entered the house, it was always campaign time." About Little Italy, Pelosi said that it was "the foundation of my life. The friendships were warm and long lasting…a sense of community."

There is barely an article, program, book or other research material about Little Italy, Baltimore, that *doesn't* mention her well-liked and well-respected father. He had his hand in everything Little Italy. "He was so great, something from another era," said Pelosi. "He was really very passionate about work and family. As a dad, he was wonderful."

# MR. JOHN'S FILM FEST

*They came over and asked if I would put a projector in my bedroom. I said, "If it's good for the neighborhood, fine, go ahead." Anything you can do for the neighborhood, you do.*

*—John Pente (1910–2010)*

A short row of white plastic chairs and two wooden benches are lined up along a side wall of 222 South High Street, seating that has welcomed countless friends, family members and strangers who once—or often—sat to chat with John Pente on the corner of his Little Italy universe.

Neighbors Dominic "Fuzzy" Leonardi, John Pente and Elizabeth Lancelotta in 2009. *Courtesy Joe Pente.*

The size of a person's universe is as big or as small as he makes it. For one hundred years, "Mr. John's" span of cosmos was entirely contained within the one neighborhood where he was born, raised, worked as a young lad, married, fathered three children and died. "I have everything I need right here," he said in a 2010 *Baltimore Magazine* interview.

Pente, a second-generation Italian, had seen much neighborly solidarity in a century. His father had passed on the Pente house to his son, purchased in about 1904 by Pente's grandparents, who immigrated to the states from Abruzzi in 1898. Born half a block away on Stiles, he grew up next door at 220 South High and attended Saint Leo's School, less than four hundred feet away. In 1930, amid the Great Depression, he graduated from Calvert Hall College High School and hit the streets looking for work. Like many of his neighbors, Pente was active in Saint Leo's Church and the Little Italy Lodge.

And although his was a simple life, his gesture was grand of allowing neighborhood organizers to haul a three-hundred-pound, bulky, six-foot-high movie projector up a twisty staircase and place it in one of Pente's

third-floor bedroom windows every summer for the last eleven years of his life. With that permission granted in 1999, the Little Italy Open Air Film Fest was born.

Why that house and why that window? It was an ideal 108-foot distance from the side wall of Ciao Bella Restaurant, holding a blank white fifteen-by twenty-foot billboard that never reached hearty approval by residents to become a mural on which to advertise restaurants.

The "blank" evolved into a "boom" as the popular Friday night event held during July and August—*Cinema al Fresco*—received global attention, as has Mr. John himself. His tiny white dog, Gina (named after the Italian movie star Gina Lollobrigida), became accustomed to reporters and camera crews knocking on the door in search of face-to-face interviews.

"It received international coverage," said Mary Ann Cricchio, proprietor of Da Mimmo and member of the Original Little Italy Restaurant Association. It was Cricchio's idea originally to show films on that empty billboard after stumbling on a similar scene in a town square in Sicily, Italy. "Mr. John was interviewed by *Good Morning America*, *People* magazine, *New York Times* and many international travel channels. I have countless videotapes of reporting not only in Italy but also Brazil, Czechoslovakia and Australia."

Now approaching its sixteenth year, the film fest continues to be media-hyped. The Italian-themed movie schedule is printed in local papers, around the Internet and on Little Italy's websites and social media pages. Television crews continued their trek to the door of the subsequent 222 South High Street homeowner, Ray Lancelotta, Pente's nephew. (Ray Lancelotta died in October 2014 during the final editing of this book.) "I wanted to keep the tradition going on, and I wanted to honor my uncle," he said in a 2012 *Daily Record* story.

The lively Friday night scene of hundreds of people seated in—and bursting beyond—the Da Mimmo parking lot at Stiles and High Streets is almost a throwback to the bygone days when it was common for neighbors to sit outside talking, eating, sharing and laughing. Quite a contrasting sight for a locale that was once a synagogue.

"Everyone giving and taking," said Pente, "this is what a neighborhood is…It does my heart good." A plaque presented to him by the association is attached to the house and reads, "Mr. John Pente; A true friend of the Little Italy restaurants and community."

# THEY CALL HIM "MUGS"

*He represents Little Italy for what it was and, in soul and spirit, still is—a place where Italians sunk their roots into this country.*

*—Paul Mugavero Baker*

The name Marion Mugavero in Little Italy is as common as pasta. Everyone knows him, and everyone eats his meatballs. "Mugs," now ninety-two, was a fixture at Exeter and Fawn Streets for close to seven decades inside his modest, elongated Fawn Confectionery store commonly known as Mugavero's—or, according to the neighborhood kids who hung there in the '50s and '60s, "Mugs' Corner." Sometimes it was so packed you just about got in.

His specialty was (what else?) meatball subs. No menu. No price list. No sides. Mugs knew what you wanted to eat before you did. "You give Mugs money and sometimes he gives you change," wrote his nephew, Paul Mugavero Baker, in his 2002 book *La Famiglia Americana*. "And you knew better than to ask for anything else. God forbid you asked for ketchup," added Joe Watchinsky. "He would lift the door on the ice cream case and yell down to a [fictional] guy in the basement, 'Ay Larry, send up a fresh bottle of ketchup!' Then he'd tell you to go wait by the side door for it."

Mugs is the son of Italian immigrants who raised their family on Fawn Street just a meatball toss away from his store; they were bakers. "To my knowledge, the bakery never had a name," said Gayle Mugavero, Mugs's daughter. "My grandparents made the bread in their house—they had big ovens—and would sell it directly out of the house."

The Mugavero family was the first in the neighborhood to have electricity. *Mamma* Mugs was born Salvatora Mogavero (note the spelling variance) and came to the United States in 1917 from Isnello, Sicily. Papa Mugs was Gregorio Mugavero and arrived here in 1914 from Caltavuturo, Sicily.

"I still remember Mugs's telephone number—LE-9-9798," said Johnny Manna, former Eden Street local. Yet his recollection might start a topic in another direction—just *why* people called the number, which caused the phone to jingle incessantly inside the legendary wooden phone booth with the rounded seat that was a corner fixture. "Everyone asks about the phone booth," said Greg Mugavero, who modernized his father's aging store in 2013 into the new Mugs Italian Bistro but moved the phone booth off site.

Bill Bertazon remembered Mugs's "famous line to anybody on the phone when he needed it: 'Let's go on the phone. Go home kid. Your mom needs you. Your brother is caught in the washing machine.'" And when he was

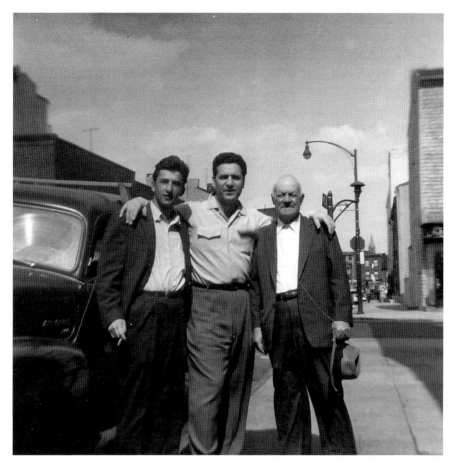

Andrew Nini, Marion "Mugs" Mugavero and Saverio Manna on Fawn Street, 1952.
*Courtesy Johnny Manna.*

in the phone booth, here was the conversation: "Mugs: 'Yeah.' Caller: '239 com a fin.' Mugs: 'Later.' And he hung up."

Bertazon was eating lunch one day in about 1967 when the police raided the store. From his perch on a counter stool, he watched a vice squad search for horse race tally slips. "After about two hours, they exited empty-handed," he said. "Mugs then took his napkin holder from the countertop, removed the napkins and handed off the slips from inside the napkin container for safe keeping off property. The man was great."

Larry Marino admitted in his 1979 BNHP interview that "in this neighborhood [there] was nothing but gamblers. Horses, numbers and all like that. Shoot dice on the street. Down the alley, shoot dice, crap games.

They gamble on anything, bet on anything. Anything that runs they can gamble on and make a dollar, they do it."

But unlike the rowdy bootleggers back in the 1920s as Marino described (see the section "Bootlegging during Prohibition"), gamblers "don't bother nobody," he noted. "Gamblers will help you. If you would go to a gambler and ask him for something, he'll give you something—they're like that."

Mugavero's naturally became a corner hangout for the youth of Little Italy. And the neighborhood as it was during Mugs's dominion was cigarettes and soda bottles, sounds of Sinatra, lunch counters, pinball machines, penny candy and Mugs never missing a day of work. If you don't know him well, you might be afraid of him. He's gruff and tough but can be as soft as the rolls he stuffed with his homemade meatballs. He yelled and chased away the kids, yet underneath he adored them.

*"Take a walk!"*

*"Don't block the window!"*

*"This isn't a library! Buy the magazine or put it down."*

*"Go find something to do."*

*"Hit the road!"*

*"Move! It's 40 acres in the back!"*

"I think that was his way of saying, 'I love you, but stop interrupting my business!'" said Deborah Di Folco.

"I enjoyed it," said Mugs. "I took care of a lot of them kids in more ways than one; helped keep them out of trouble."

Mugs isn't a fan of the changes he's witnessed in the community. He's watched the transformation of a neighborhood that once consisted entirely of families. "Years back, we had everything," he said. "It was all families down there. It was different. Things fade away. People who live there now are a different breed. Now there's no more kids, no more school."

Perhaps the best way to learn about the irreplaceable Mugs is to hear stories from the former kids who experienced him. Their memories of Mugs are delightful.

The old man ventures in occasionally, cane in hand, to sit under the black-and-white vintage photos in handsome black frames that dot the bistro's walls—photos of the neighborhood as it was. Nearby is his son Greg, who carries on the meatball sub and sausage sandwich legacy that his father began in 1947.

If you're lucky on the day you eat there, you could spot Mugs…a little skinnier, a little older and a little tired, yet still with spunk. "He loved his boys on the corner, no doubt," said Bill Bertazon.

# LARRY "KILLER" MARINO

*Larry was just a down-to-earth good old guy that tried to help everyone in his sight. Even though he was big and rough and tough, he was very soft-hearted.*

*—Anna Giorgilli D'Adamo*

No surprise that he became a boxer since Larry Marino (1917–1981) was always getting "banged on" as a kid—beat by nuns, brothers and playmates. "A lot of fighting; always fighting," he said as he described how he was often in trouble at school (which he "hated"). Perhaps fighting was in his genes.

Naturally left-handed, the nuns used to tie down his left hand so he couldn't write with it, yet that act only angered him, so he often skipped school to earn a few pennies unloading bananas on the waterfront docks. His truancy eventually landed him in Saint Mary's Industrial School, a school for "bad boys," where he spent five months.

"Every place had gangs and every neighborhood had fighters, see? And that's the way it started," said Marino in his 1979 BNHP interview. "We used to go to West Baltimore and fight the West Baltimore gang. Italians go fight the Lexington Market gang…lots of street fights. Most of them start in dance halls."

Did anyone beat him up in the neighborhood? "No, they didn't beat me up because if they beat me up, I'll get them the next day, beat them again."

In those days of his youth, he said that different "gangs" territorially hung out corner to corner in Little Italy: the Butta gang on Eastern and High, Luke's (others called it Luge's) gang on Fawn and High (now Sabatino's), Rhode Island's Corner at Albemarle and Stiles and a fourth gang at No. 2 School at Central and Pratt. "You belonged to the corner where you lived the closest," said Marino, part of the "Rhode Island" corner named for the state the Lancelotta family hailed from before opening their corner store.

And who decided when they were going to fight? "Right when you opened your mouth…you got busted up," he said.

Marino's amateur boxing start was in "little fighting clubs" that cost pennies to get in. It was during the Depression, when no one had money. "Nobody had nothing," he said. He was trained in the neighborhood by Al Lang, who "taught me right here on Pratt Street. He had a gym across from the stable." Marino then was about eleven years old as Lang put him in the "smokers" to fight. "Just two kids…fighting it out while people watched,"

"Rhode Island Corner" at Albemarle and Stiles Street was nicknamed as such because the owners, the Lancelottas, had moved there from Rhode Island in 1925. They had nine children. This locale was also once Vaccarino's store. *Courtesy Apicella family.*

said Marino, "putting on a show. Like in a carnival." Kids were paid with a pair of shoes, pants or a shirt. No money except for the coins the boys snatched off the floor when spectators tossed them.

The amateurs who didn't want to quit boxing, like Marino, turned professional in 1932. He fought as a welterweight and light heavyweight, paired in main events with several ranking boxers. During his career, he had a three-piece band in his entourage. If he won a match, the band would play the tune "Margie"; if he lost, it would play a funeral march.

Their mother hated the idea of him fighting, said his sister, Anna Giorgilli D'Adamo, eighty-four, the baby of thirteen children and the lone survivor. "I remember her saying to him, 'Don't go, Larry. You're gonna get hurt.' One night they brought him home on a stretcher."

Marino may have been a rebel, but he proved himself well later as one of the nice guys. He cared for the flags while active with the Star-Spangled Banner Flag House Association and, for this work, received a Baltimore's Best Award in 1979. "He loved his flag," said Anna.

Before he retired as a longshoreman, he became the volunteer director at Saint Leo's playground, no longer as "Killer Marino" but as "Mr. Larry," teaching kids boxing, soccer, basketball and other sports. "He had a boxing ring in the parking lot where the lodge is now," she said. "He was very

generous with the kids. Everyone knew him. He loved kids, even though he never had any of his own."

He taught boxing even to the little ones, to teach self-preservation, have fun and know what it's like to fight, said Marino in a 1975 *Sun* interview. "Larry 'Killer' Marino taught all of us kids how to box," said Ray Alcaraz, who grew up on Stiles Street and is still active in Little Italy. "He set up punching bags in the playground and provided gloves."

He was a big deal in his day, recalled his nephew, Bill Bertazon, known as "Killer's nephew," who said that his uncle fought many fights and was a contender for the title. "I always felt proud of his stature. He once told me corruption made him retire from the boxing industry. The man had a soul. And he loved his mother." Larry took care of her until the day she died.

# We Love Lucy

*Working the fried dough stand with Mrs. Lucy Pompa and her son Vince meant a day making people smile as you handed them still-warm pieces of powdered sugar fried dough.*

*—Cara Tana Walen*

Fresh soft dough for ravioli and fried dough weren't the only things Lucy Pompa had her hands in. As a longtime resident in the neighborhood, she has been immersed in just about everything at her much-loved Saint Leo's Church, including the Saint Leo's Mother's Club and Sodality of Our Lady, to name a few.

"We did a lot for the church. I love that church," said Lucy with a glint in her eye as she fondled the cluster of gold religious medals around her neck. "It's beautiful. We need to keep it up. That's our church." She recalled sorting clothes for the poor with the late Anne Gentile, her friend and neighbor. "Bundles and bundles," she said. And she recalled the effervescent pastor, Father Mike Salerno (served 1997–2007), a priest who had made quite a big impact on the small neighborhood. "I miss him, Father Mike. He was the best priest of all of them."

Saint Leo's Church is a parish locked within Miss Lucy's heart, the place where her immigrant parents were married, where she was married, where her boys served as altar boys and where a plethora of other sacraments took place for the Pompas.

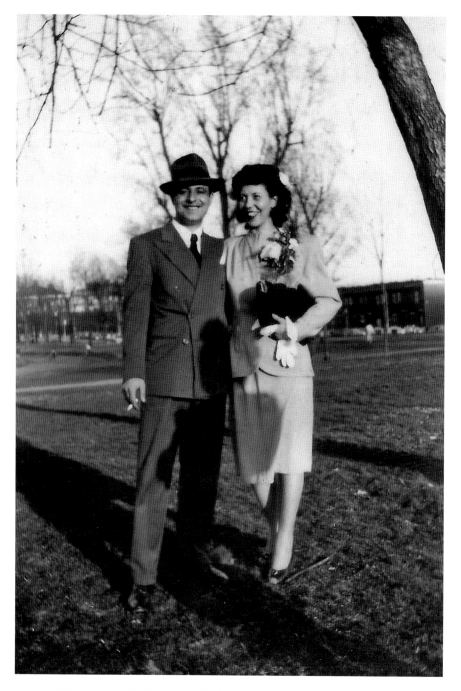

Vince and Lucy Pompa, the "Queen of Ravioli," circa early 1940s. *Courtesy Pompa family.*

The church sits mere steps away from her house on South Exeter Street—the same house in which her husband, Vince Pompa, was born and where he and Lucy raised Dominic, Roseanna and Vincent Jr. The couple married in 1948, and after almost fifty years of marriage, Vince died in 1997. A gold wedding ring is permanently embedded on her left hand.

For many years, Lucy was president of the Saint Gabriel Confraternity; her father-in-law, Dominic Pompa, had been one of the original founders. Her son Dominic serves as its current president. "I always took part in St Leo's," she said, "I belonged to all of the societies." A common sight at the years of festivals and fundraisers was Lucy and Vince Pompa working side by side. Not only did the ravioli but also the fried dough belonged to her. Many volunteers correlate working the fried dough stand with Miss Lucy, where she says, "All of my family helps with the fried dough at the festivals. And Chiapparelli's donated all the dough."

In her old kitchen, she's wearing a red sweatshirt and a gold Italian horn (*cornetto*) around her neck; a walker sits in the corner, testimony to the fact that the ninety-six-year-old parishioner can't zip around the blocks of Little Italy as she once did. Her smooth skin seems to indicate she's fibbing about her age. While it's impossible for her to assist at Saint Leo's as much as she would like, Lucy still likes her kitchen, as most Italians do.

"I still cook a little. Nobody starves," she said. "But I can't do what I wanna do anymore. My mind ain't what it used to be. My daughter looks after me." She spends much of her day crocheting items like afghans, a craft learned from her mother. "It keeps my mind and hands working. You gotta keep busy."

One of nine children (three still alive), Lucy was only fifteen-years-old when their mother died of pneumonia. It was necessary for her to leave school at an early age to care for her brothers and sisters. As a result, "my mother always preached education and how important it was for her children to complete their schooling," said Dominic. "She was proudest whenever any one of us graduated from an institution of higher learning."

Lucy's mother was born in Casalvecchio di Puglia in Foggia, Italy; her father was born the next village over. "They came to America on the same boat. Although they knew each other, they were not together," said Lucy. "My mother lived in Little Italy with relatives."

The couple, Nicholas and Rose Palmere, later fell in love, were married at Saint Leo's and settled into the Italian community. Later, they moved to Highlandtown, where Lucy was born; she returned to Little Italy when she married. "I loved it, moving here. I had a lot of friends here; they are all passed away now."

From her parents, she learned the importance of helping others willingly, and she delved into the ministries of Saint Leo's. She welcomes into her home four grandchildren and neighborhood friends who may tap on her door to say *ciao*. Exeter Street is where she is most comfortable, the home in which she has served as a homemaker.

At the two parish homeless dinners held near Thanksgiving and Christmas, Lucy's customary post is standing at the antique metal red desk (a Church Hall fixture seemingly since the days of Jesus) handing out new white tube socks to the clients as they leave.

She lived in Little Italy during the hard times and the happy times. "The neighborhood was altogether different than it is now. People were very poor. The neighborhood was very poor. Not many restaurants. It even looked poor. They had nothing. It wasn't easy for them. We all managed to get together and help each other. We shared. If you got tomatoes and had a lot, we gave some to our neighbors."

"I like to believe that when my mother arrives in heaven," said Dominic Pompa, "God will put her in charge of His kitchen."

# Chapter 7
# *Cristoforo Colombo Arrives in Baltimore*

*Americans of Italian descent have given a great deal to this country…I'm pleased to be here in Little Italy with you to honor a man who reminds all Americans that we must always strive for the best, to push to the limits and beyond.*
*—President Ronald Reagan*

Italians want to honor Italians. Especially an Italian sailor whose role in history dates back to 1492; even if *Cristoforo Colombo* died before realizing he had encountered an entire continent (first stumbling upon what is now the Bahamas).

It seems fitting that the first influx of Italians to Baltimore were *Genoese*, given that the alleged discoverer of America was born in Genoa, Italy, and that Baltimore was the first city in the United States where a forty-four-foot Christopher Columbus obelisk was erected in Druid Hill Park (then a Baltimore County estate) in 1792 on the occasion of the 300th anniversary of Columbus's voyage. Its marble inset read, "Sacred to the Memory of Chris. Columbus / Octob. XII / MDCC VIIIC."

In 1892, Italian United Society of Baltimore erected a second Columbus monument overlooking Druid Lake after aborting identity with the first one, which over the decades had faded into the shadows. Its inset reads, "To *Cristoforo Colombo* / The Italians of Baltimore / 1892."

"Baltimore is probably the only city in the world with so many Columbus monuments," said Sam Culotta, past president of a local Sons of Italy, in a 1992 *Baltimore Sun* story. "I don't think even Genoa has three." This native of

Ceremonies honoring Christopher Columbus were once held at Druid Hill Park, where two statues were dedicated. The commemoration is approaching its 125th year in Little Italy. Pictured behind the wreath is then mayor Tommy D'Alesandro Jr., October 12, 1956. *Courtesy Denise Giacomelli Loehr.*

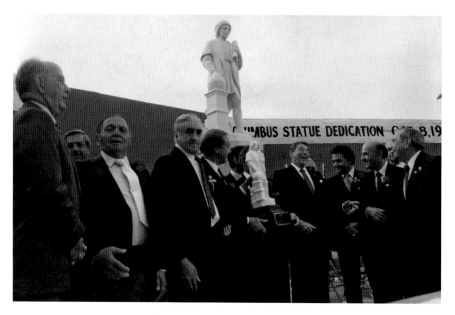

The 1984 dedication of Columbus Piazza on President Street by President Ronald Reagan (center) as he is presented with a miniature statue replica. Far left is then mayor William Donald Schaefer. *Courtesy Dominic Averza.*

Italy, now ninety-one, who immigrated to Baltimore at age nine has been in sixty-seven marches since 1946, said during the 2014 commemoration when he served as the parade's grand marshal, "I'm an old fashioned Sicilian traditionalist. It's a feeling of love of a family."

A third statue stands in the most suitable of Baltimore settings—Columbus Piazza in Little Italy—appropriately near the settlement site of the many immigrants who arrived from Genoa, like Columbus himself. "It was a great day, a great honor, with the president being there," said Dominic Averza, referring to President Ronald Reagan, who dedicated the new *piazza* and statue in October 1984 in a high-profile public ceremony, along with then mayor William Donald Schaefer.

Dominic served on a committee with ten men, beginning in about 1977, to plan the spherical *piazza* on President Street encircled with twenty Italian flags representing the provinces in Italy. F&M Contractors (Frank Marcantoni) physically constructed it. For the statue's design, committee member Carl Julio had visited Carrara Marble Company in Italy to have a smaller replica fabricated. Once the committee approved the design, the statue was produced at a cost of $25,700 and shipped to Baltimore. Miniature statues were also made and presented to committee members and to President Reagan.

The Italian Carrara-marbled statue seems to pose taller against the blue sky every October during a ceremonial homage in which a few dozen local civic (mostly Italian) organizations are invited to lay floral wreaths at its base in honor of Columbus. This event is preceded by a Mass at Saint Leo's Church and succeeded by a brunch in Little Italy; then a parade runs through the streets of the city, ending in Little Italy.

Columbus Celebrations Inc., led by Chairman Alfredo Massa, organizes the celebration. He acknowledged Italian community members such as Carl and Dominic for maintaining Columbus Piazza "throughout these past thirty years…taking the responsibility to make sure that it is presentable for our annual ceremony."

Baltimore has the distinction for hosting the longest continuous Columbus parade and commemoration in the country since 1890—approaching its 125th (at time of writing). Although the parade's locale, size and pomp and circumstance have changed considerably over the decades, what hasn't changed is the endorsement of the celebration by Baltimore mayors and state dignitaries. Assorted Italian-related organizations continue to march (Knights of Columbus since 1921), and Italian pride and heritage shine through via green, white and red floats, flags and pageantry. More elaborate

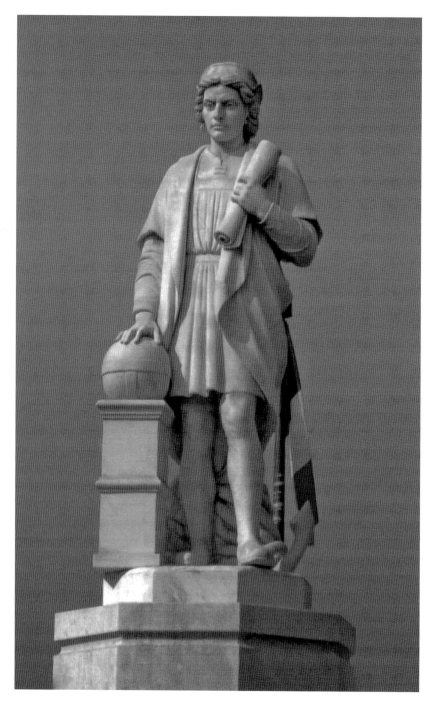

Christopher Columbus statue in Columbus Piazza on President Street. *Photo by Thomas C. Scilipoti.*

parades were once held compared to the ones today. In 1992, Joe DiMaggio once served as grand marshal.

A 1952 *Baltimore Sun* story described a two-mile-long procession as the "biggest celebration in the city's history," with thousands of Italian Americans among eleven thousand spectators. Officials proclaimed it the "greatest tribute Baltimore has ever paid to Christopher Columbus." More than one hundred organizations were on display, and the reviewing stand was in Druid Hill Park. On it was Mayor Thomas D'Alesandro Jr. (His son, Tommy D'Alesandro III, has served as chairman of the Mayor's Columbus Day Parade in the past and continues to participate in today's commemorations.) Then thirteen-year-old Frank Velleggia and Vito Martino Jr. placed wreaths at the foot of the monument; celebrations continued into the evening at Sons of Italy, Knights of Columbus and Italian American Civic Club halls.

In 1912, the parade formed at Broadway and Baltimore Street. In 1932, it contained two thousand marchers and started in front of the Order Sons of Italy hall (then located on Saint Paul Street). The parade proceeded to Druid Hill Park, where a concert was held at the monument.

Making history of his own, the bearded Donald Castronova, whose grandparents lived in Little Italy, portrays Christopher Columbus in the annual parade and has done so for forty-three years. "I have had the honor of

Donald Castronova has portrayed Christopher Columbus in Baltimore's Columbus Day Parade for forty-three years. *Photo by Thomas C. Scilipoti.*

portraying Christopher Columbus, a man whose perseverance and courage led to the discovery of the New World and changed the whole world…for the good!" said Castronova. "I am proud to have been part of this celebration and hope to join the Italian American community in continuing to show our pride in our heritage."

Columbus Day celebrations may not ever mount to the merriment level of the green beer–drinking Irish on their beloved Saint Patrick's Day, but in Baltimore's Italian community each October, to honor *Cristoforo* is to honor being Italian.

## Chapter 8
# Bocce, Very Italian

*It's just a wonderful night. It's less about competition and more about friends coming together for a friendly game.*

—*Giovanna Blattermann*

In simpler days, there weren't many Italian picnics or family gatherings that didn't include bocce. Considered the oldest known sport in world history, bocce is the third most-participated sport (after soccer and golf) in the world. Popular throughout the United States among Italian Americans for nostalgic reasons, this game of skill and strategy dates back seven thousand years. Some historians claim that the Egyptians played it as early as 5000 BC and that the Romans adopted it from them. Others claim that the Greeks were responsible for bocce making its way to them from Egypt around 800 BC.

The word *bocce* stems from the Latin *bottia*, meaning "boss"; it is plural in Italian for the word *boccia*, which means "bowl." The object of the game, usually played on a stone dust court, is for a two- or four-person team to roll four larger red or green wooden balls as close as possible to a small ball (*pallina*) and be the first to score twelve points. Officials settle distance disputes with measuring tapes; in vintage days, they used string. The game combines the skills and strategies of bowling, shuffleboard and billiards.

In the 1930s, bocce tournaments were played around Baltimore by teams of the Seventh Ward Democratic Club and the East Baltimore Roman Bocce Club. The former Northern Italian Pleasure Club at 1010 Pratt Street had an outdoor bocce court.

Neighborhood resident and bocce instructor Joe Scalia at play on the neighborhood's popular bocce courts. *Photo by Thomas C. Scilipoti.*

In the heart of Little Italy on Stiles Street are two bocce courts that seem to help unify the community. Located in D'Alesandro Park (owned by Baltimore City Department of Recreation and Parks and named in memory of the late Thomas D'Alesandro Jr., Little Italy resident and former three-term Baltimore mayor), the courts were installed in 1994, moved from a prior location near the pumping station. The current bocce park once served as a Saint Leo's School playground; before that, contractors stored war-surplus trucks and equipment there after World War I; long ago, the site was also a rag shop owned by a Jewish enterprise.

The former bocce courts near the pumping station evolved when Councilwoman Barbara Mikulski wanted "to show faith" to the Italian community and, alongside Councilman Mimi DiPietro, had them installed by the city on a vacant lot that was once a recreational field and a fond memory for many kids who grew up in Little Italy. Courts were kept under lock and key, but "one person on every street corner in Little Italy had a key to get in," said Elia Mannetta, a current resident.

The city provides utilities at the Stiles Street location; volunteers from Little Italy's two leagues maintain and groom the courts by removing divots, painting fresh lines and raking, leveling and watering the stone dust—optimal for a good roll.

Bocce player and teacher Joe Scalia, eighty-seven, a native of Palermo, Sicily, who immigrated to the States in 1950, learned the game as a boy and teaches bocce on Saturdays at the Pandola Learning Center in Little Italy. He lives a bocce ball's roll from the courts. As originator of the former Little Italy Bocce Rollers Association (LIBRA), he helped establish the first league in Little Italy and the start of the tournaments held during neighborhood Italian festivals.

"He's the godfather of this game," said Giovanna Blattermann, co-coordinator for the Tuesday and Wednesday night Little Italy Bocce League, along with her brother-in-law, Francis Blattermann; Sal Petti; Sal Spinnato; and Bobby Zelkoski. "His voice, his connections…the rest is history. If it were not for Joe, we wouldn't be here today."

As a young girl, Blattermann, also a native of Sicily, remembered watching men from the neighborhood play bocce. "They wouldn't let us play," she said. Years later, she helped to form Team Gia, the first all-female team in Little Italy, with her neighbor, Rosie Apicella. Now in her eighties, Rosie lives on Fawn Street and knows all about the game she's been playing for most of her life. "She's one of the better players," said Dino Basso.

Two leagues currently occupy the courts: Little Italy Bocce League, as mentioned, and the Italian American Bocce League on Thursday nights, led by Basso. The late Robert Marsili was instrumental in establishing the league with Basso in 2007. As a youngster, Basso remembered watching his father play bocce with *amici* from the old country.

In the neighborhood, bocce games and tournaments provide an attention-grabbing attraction for tourists. The bright red, white and green benches are quite noticeable. During the church's festivals, the courts are *packed*.

This pastime continues to offers residents and visitors a dose of camaraderie and a sense of community that surpasses age or language.

Customers of La Scala Restaurant can enjoy playing bocce in its indoor courts on Eastern Avenue. Bocce also attracts many former residents back to Little Italy—a neighborhood where they once lived, played and attended school, like siblings Carol Ann, Johnny Wayne and Gary Molino, who grew up on Eden Street and are members of Team *Cugini* with other Molino cousins. "When I play bocce in my old neighborhood," said Gary, "I feel connected not only to Little Italy but all the way back to the mother country."

# Chapter 9
# *All in an Italian's Day of Work*

*I remember when we would visit Aunt Maria and Uncle Mario at their Maria's Restaurant in Little Italy. I can still see my Aunt Maria sitting on a barstool in the kitchen stirring the sauces or rolling the pasta. The smell of the long-simmering fresh tomatoes, the gooey texture of fresh pastas between my fingers, the sounds of Max on the accordion.*
—*Stephanie Allori Hillis*

We would need something similar to a genealogy chart to map the course of Little Italy restaurants, street merchants, trades and businesses over the almost century and a half of the neighborhood's existence. This owner here started there as a busboy…that head chef formed a partnership to open a new restaurant with this manager…one couple sold property to another, who opened a storefront unrelated to the previous business. And many early "restaurants" were simply homeowners feeding their boarders.

The food industry in the neighborhood expanded as a result of the economic pressures faced during the Depression. Until the mid-1930s, there were few restaurants, such as Roma's, that attracted nonresidents. And even Roma had its start as Giovacchino Babusci's grocery store on 913 Fawn Street (circa 1915). After Babusci began to serve ten-cent soup and spaghetti to hungry customers, his daughter Emma convinced her father to turn the store into a restaurant, credited as the first Italian restaurant in the neighborhood (it then moved to 900 Fawn). He was formerly a chef at Morisi's on President and Eastern Avenue. Emma, the hub of the business,

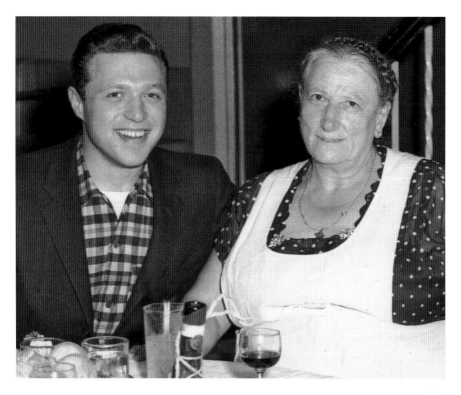

*Mamma* Emma Macciocca and entertainer Steve Lawrence. *Photo by Thomas C. Scilipoti.*

then married a chef, Angelo "Mike" Macciocca, who added recipes such as chicken cacciatore and veal scaloppini.

"When they're hungry, they come to Roma," said *Mamma* Emma in 1965 about the celebrities she had served, such as Jane Russell, Tommy Dorsey, Mickey Mantle, Steve Lawrence and Frank Sinatra.

"Emma's culinary talent, preference for only choice ingredients and 'secret' family recipes transformed the Roma into one of Baltimore's premier restaurants," wrote Rosalia Scalia in a 1986 *Italian Times* story. "By 1947 this reputation had spread across the east coast, attracting celebrities from the worlds of music and film." Emma died in 1976; the restaurant remained open for a short while after.

Often the vocation of running a Little Italy restaurant remained all in the family, and this is true even today. Mothers and fathers, sons and daughters, husbands and wives, cousins, aunts and uncles together toiled and sweated to whip up delectable dishes and recipes perhaps once used in Italy, as well as, of course, to earn a living. Children were introduced at young ages to

kitchen and dining room duties and frequently took over their parents' restaurants upon death or retirement. Many of the restaurateurs lived in apartments or homes above.

An early tavern and boardinghouse was run by Jack Pessagno; other neighborhood saloon keepers were DiNardo, Lancione, Gambardel, Bowmans, Lazzaro, Rattini, Lamm, Peterra, Pizza, Baroni, Del Pizzo and probably dozens more not unearthed in research.

Restaurants included Maria's (originally the Italian Village), which was opened in 1934 by Maria Allori, who served hundreds of celebrities, as did the renowned Velleggia's, a favorite dining spot for many Baltimore Colts players after home games in the '60s and '70s. Velleggia's was run by three generations and was initially opened as Enrico's Friendly Tavern in 1937 by Enrico and Maria Velleggia. From Tino's on Eastern Avenue, which was opened in 1963 by Anthony and Teresa Bastianelli (he was formerly a busboy at the Roma), who built an Italian roof garden, claiming it was the only one in Baltimore, to the Roma itself on Fawn and High Streets, run by the vivacious and lovable *Mamma* Emma Macciocca mentioned earlier. From Rocco's Capriccio (formerly Kid Julian's Italian Kitchen, then Capriccio), owned by Rocco Gargano from Matera, Italy, to DeNittis on Trinity Street, once a German church and then the garage and office of Arundel Construction Company, operated by the Corasaniti brothers.

There was Bella Roma, Boccaccio, Café di Roma, Caesar's Den, Iggy's Sandwich King (a favorite of Governor William Donald Schaefer), La Trattoria Petrucci, Manna's, Mamma Celina's, Palughi's and Morisi's. There was DeMann's hardware, Gramegna's Bakery, Trombetta's ice cream push cart, Granese Memorials, Kemp's grocer, Morganstein's Jewish bakery, Naddeo Brothers jewerly and watch repair and countless other eateries, commerce and merchants who once walked and lined the streets.

# THE LAST HURDY-GURDY

*I saw many, many changes. We had everything here.*

−*Gene Schiavo*

Grandfather Cirelli couldn't read or write and signed the "X" until the day he died, but he knew when a musical instrument was out of tune. That included his beloved wooden hurdy-gurdy, a musical organ box he pulled up, down

This hurdy-gurdy, once pulled daily around Baltimore by Charles "Chess" Cirelli, weighs 648 pounds, not counting the wagon. Cirelli's grandson, Anthony "Corky" Schiavo, showcased the instrument in Columbus Day parades. *Photo by Thomas C. Scilipoti.*

and all around town for close to fifty years. As the performer turned the crank in tempo to the music, pleasing melodies floated out from its paper roll inside the encasement, a sound similar to bagpipes.

"It is a heavy thing, like a piano. It weighs 648 pounds, not counting the wagon. Pulling it is hard work," wrote Charles "Chess" Cirelli in his 1959 *Baltimore Sun* story. "Sometimes, about once a week, I used to go clear out to Towson. Walk all the way, pulling the hurdy-gurdy, stop and play a while, then pull some more. Like a horse."

Cirelli didn't remember the names, only the numbers, of the songs he offered, such as "O Sole Mio," "Oh Marie," "La Paloma," "Pennies from Heaven," "Alice Blue Gown" and "Sidewalks of New York." "You have something you like to hear, tell me the number. All pretty."

Out of the sixteen hurdy-gurdies that he and his brother, Antonio Cirelli, once owned, there is one treasured instrument remaining in Little Italy as of this writing, resting under a tarp in the garage of his grandson Gene Schiavo (who died during the proofing of this book). Gene inherited it from his grandfather, the Italian who loved music but hated monkeys and bears (animals commonly trained as street performers). Charles disliked being called an organ grinder, like the other organ grinders who lived on "Monkey Row" (Slemmer's Alley) in Little Italy. His grandsons used to sing a song to him about monkeys, knowing that it would irritate him.

"My father was an organ grinder," remembered Cirelli. "Over in the old country, Genoa. I used to go with him. My mother, my brother, my brother's wife—all of them played the same kind of music I do…I never took a monkey with me. No, sir. I don't like monkeys. Bears either."

The Cirellis had emigrated from Genoa, Italy, when Charles (born 1880) was age seven and Antonio fourteen; three more brothers followed

later. As young adults, they eventually saved money and began to accumulate one hurdy-gurdy at a time, renting them out for a dollar a day. They housed them in sheds on property they owned on Eastern Avenue. Chess and Tony each worked a route to earn coins that appreciative people tossed their way—sometimes out of windows—as the tunes rolled by. Tony ventured out daily to higher-income areas, specifically Bolton Street, beginning his entertainment "season" each spring. Chess stayed behind some days to service the instruments, oiling, washing, tuning and shining them.

"That was his life, his hurdy-gurdy," said Anthony "Corky" Schiavo in his 1979 BNHP interview. "As a kid…I used to wait for him to come home at night and we used to sit around a table and count the money. Very seldom more than a nickel. Once in a while we would see a dime or a quarter. Some days he'd have $3.50. Some days he had $4.00. Some days he had $2.75. And that would be all day. But he would also come home with a lot of produce. Fruit, bananas, apples, oranges, loaves of bread, canned goods that sometimes people would give him."

Some weekends—only on a Saturday—Cirelli would take young Anthony with him. "That was the only day I could go with him," he said. Weekend work would be shortened from the musician's usual twelve-hour shift, although it was beneficial to have his young grandson along to help pull the hurdy-gurdy uphill. "It's on two wheels…heavy but it's balanced well, that one man can control it," said Schiavo. "I was his mascot."

New inventions and technology eventually caused the Cirellis' street music to perish. Phonographs replaced street performers. Radio grew larger, and then stereos came along. "You would walk along the street and you would stop and play, but nobody would open the windows upstairs to listen and throw money," he said. "There was nobody home. All the women had jobs."

Ultimately no one rented the instruments anymore, and Cirelli sold them off one by one, "mostly to rich people in Guilford who put them in club cellars. Maybe they play them and maybe they don't." Cirelli pulled and played the hurdy-gurdy until it was too strenuous on his heart to do so. Like his grandfather, Gene used to haul out his grandfather's instrument during the neighborhood's Italian festivals. It eventually became too heavy for him as well.

That last hurdy-gurdy is quiet now. It did its job, played its tunes and made people smile as it cranked out many a happy song to the delight of its listeners.

# ICONIC RESTAURANTS (1945–2002)

*Maria's…most famous and best of all the Italian restaurants. Actors,*
*movie stars, glamour girls, all the famous and ritzy people packed the place.*
*—Angie D'Amico*

Countless celebrities have stepped into Little Italy to enjoy a meal: presidents, vice presidents, politicians, actors, singers, entertainers, comedians, musicians, sports celebrities and professional athletes. Currently there are close to thirty restaurants, bakeries, bars and carryouts in Little Italy—mostly Italian but not all. Brief backgrounds are included here of the older, iconic Italian establishments, with Chiapparelli's as the oldest, established in 1945.

ALDO'S RISTORANTE ITALIANO (1998), Aldo and Sergio Vitale, proprietors. Chef Aldo was born in Calabria, Italy, and immigrated to the United States in 1961 at age sixteen. He was raised in a family where the kitchen was the center of daily life, and it was there where he became inspired to study culinary arts. He honed his skills in Tuscany, where he was stationed while serving in the U.S. Army. Inside his restaurant, constructed from two abandoned row houses, the chef crafted its intricate woodwork, including the mahogany bar. Aldo's son, Sergio, partners with him to operate their award-winning restaurant.

AMICCIS OF LITTLE ITALY (1991), Roland Keh and Scott Panian, proprietors/chefs. Keh is a Little Italy native who grew up across the street from Amiccis, attended Saint Leo's School, served as an altar boy at Saint Leo's Church and worked in Little Italy his entire life (for Sergi's Ice House, Vaccaro's and Chiapparelli's). His grandparents were Salvatore "Shorty" Trombetta, a legendary pigeon racer from Salerno, Italy, and Alice Trombetta, who also lived in Little Italy. Keh's parents, Dolores and Rolando (an Amiccis chef), still reside in the neighborhood.

CASA DI PASTA (1970). The Velleggia name in Little Italy goes back to 1937, when Italian immigrants Maria (D'Angelo) Velleggia from Acquasanta, Italy, and her stonemason husband, Enrico, from Porto San Elpidio (a village on the Adriatic Sea), were proprietors of Enrico's Friendly Tavern. Maria, known as "Miss Mary," made everything by hand. The small corner tavern was later transformed and renamed the landmark four-hundred-seat Velleggia's restaurant, the oldest restaurant in Little Italy until it closed in 2008 (it transferred ownership in 2005). Across the street, Velleggia's Casa di Pasta is a retail and wholesale fresh pasta business that has been a Baltimore

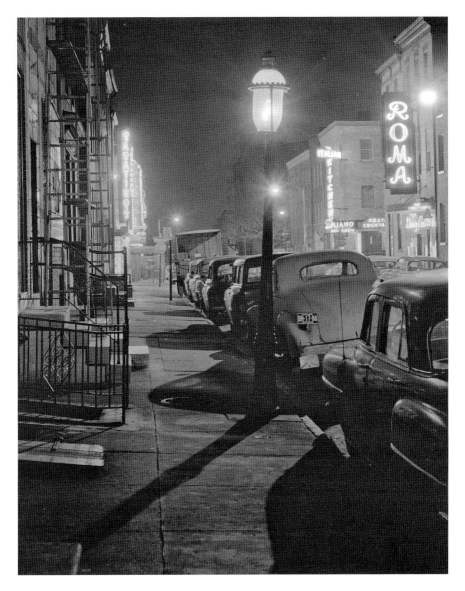

A 1957 view of a gaslight streetlamp amid restaurant lights near High and Fawn Streets. *Photo by Thomas C. Scilipoti.*

landmark since 1970, with Frank Velleggia Jr. at the helm along with his father, Frank, once the proprietor of the family restaurant. Their delightful "best kept secret in Little Italy" is a store on Albemarle Street. There they produce all types of fresh pasta products and stock fine-quality Italian

Perry Como visits Pizza's Restaurant, 1953. *Photo by Thomas C. Scilipoti.*

groceries and specialty items, such as imported olive oil and vinegar, Italian bread, cheeses, meats and Italian sweets.

CHIAPPARELLI'S ITALIAN RESTAURANT (1945), Bryan Chiapparelli, proprietor. Pasquale Chiapparelli arrived in America from Naples in 1925 at age 26 when there were only two Italian restaurants in Baltimore. In the early 1940s with his brother, Vince, he opened the Vesuvius at the corner of Albemarle and Stiles Streets; it was closed in 1942. He then opened Chiapparelli's at Fawn and High, where pizza was the main fare. Pasquale married Anna Mary Pizza, better known as "Miss Nellie," who lived to almost age 101.

CIAO BELLA ITALIAN RESTAURANT (1991), Anthony Gambino, proprietor. It was founded by Chef Anthony Gambino Sr. (who died in 2001), the son of immigrants from Palermo, Sicily. He built the restaurant with the help of his son, Chef Anthony Gambino Jr., who continues his father's legacy in the heart of Little Italy.

DALESIO'S OF LITTLE ITALY (1985), Paul Oliver, proprietor. Established by Michael and Cindy Dalesio, who stem from noble families of Italy in the Piedmont region, the husband-and-wife team operated the restaurant (formerly Corbi's) until 1989. It was then taken over by their former general manager, Paul Oliver, whose family surname was once Oliveri; his father's

family is from Milan, Italy. Paul continues the operation of Dalesio's, as it prides itself on Northern Italian cuisine and fresh seafood entrées. The accommodating, romantic setting in three former townhouses serves Italian standards along with good wine and decadent homemade desserts.

DA MIMMO ITALIAN RESTAURANT (1984), Mary Ann Cricchio, proprietor. Cricchio established Da Mimmo with her late husband, Mimmo (who died in 2003), who emigrated from Palermo, Sicily, in 1957. She carries on her husband's traditions with their son, Mimmo Jr. The Cricchios had renovated the building themselves, and eventually their restaurant's motto was "Dine with the stars," for the plethora of celebrities who have eaten there. Dozens of autographed photos line the walls. Mimmo was the original owner and founder of the Caesar's Den restaurant in 1970 and sold it to his brother, Nino Cricchio, in 1982. Nino's son-in-law, Guido DeFranco (and wife, Tina), ran Caesar's until their retirement in 2013.

GERMANO'S PIATTINI AND CABERET (1978), husband and wife Germano Fabiani and Cyd Wolf, proprietors. Germano was born in Florence, Italy, and came to the United States in 1975 at age twenty-eight. Three years later, he purchased the property that was a bar and gambling establishment known as Casa Bianca and opened Trattoria Petrucci. In 1990, he changed the name to Germano's Trattoria and added an upstairs dining room that has served as Baltimore's premier cabaret for local and national live music and theater performances since opening in 1998. The restaurant underwent another renaissance in 2013 as Germano's Piattini, a contemporary Italian kitchen and bar that serves small plates of antipasti, pastas, charcuterie and Mediterranean specialties.

LA SCALA RISTORANTE ITALIANO (1995). Chef/owner Nino Germano was born in Bafia, Sicily, and with his parents, Mico and Pina, joined relatives in Baltimore in 1974 at the age of nine in search of their American dream. Nino has accomplished his with La Scala, which started as a cozy thirteen-table restaurant and has expanded and transformed into a historic stop in Little Italy for true authentic Italian food.

LA TAVOLA RISTORANTE ITALIANO (1997), Michael Goldsmith, owner/ general manager, and Chef Carlo Vignotto, chef/owner. A Long Island native, Michael joined original proprietor Sam Azoulay at La Tavola in 1998. Carlo, born in San Dona di Piave near Venice, Italy, joined the team in 2000. The fourth owner/manager, Michael Papa, has been with La Tavola since 2011. The restaurant continues to operate on the premise of serving only the best Northern Italian–influenced cuisine, with an emphasis on homemade pasta and fresh seafood entrées.

Some New York Yankees visit Roma Restaurant, circa 1950, after playing the Orioles: Bill "Moose" Skowron (on left), Whitey Ford (with cigar) and Mickey Mantle (seated), age nineteen. Others are Eddie Lopat, pitcher; Charlie Silvera, catcher; Joe Collins, first baseman; and Frank Sansoti. *Photo by Thomas C. Scilipoti.*

MUGS' ITALIAN BISTRO (1947), Greg Mugavero, proprietor. You can still hang out on Mugs' Corner, and you can still chat with Mugs (see "They Call him 'Mugs'"). The infamous phone booth may be gone, but not the marvelous growing-up memories of the former Mugavero's Confectionery, begun by Marion Mugavero, since renovated and taken over by his son in 2012. Mugs's yummy meatball subs are still available.

PIEDIGROTTA ITALIAN BAKERY & PASTRY SHOP (2002), Carmenantonio and Bruna Iannaccone, proprietors. These natives of Italy (Avellino and Treviso, respectively) work on the easternmost edge of the neighborhood and offer patrons much more than their shop's name implies. Breakfast, lunch and dinner, handmade by Bruna, is ready-made behind the glass in this large yet cozy space. Dessert is tempting piles of cookies, cakes, multi-colored gelato and tiramisu, which Carmenantonio claims he invented in 1969. In Ponte di Piave, Italy, he operated his original Piedigrotta shop.

Neighborhood kids typically hung out at various corners such as Luge's Confectionery (pictured, now Sabatino's Restaurant). *Photo by Thomas C. Scilipoti.*

SABATINO'S ITALIAN RESTAURANT (1955), Vince Culotta, Renato Rotondo and families, proprietors. Sabatino's building was formerly owned by Luca Granese, who operated Luge's Confectionery, a popular neighborhood hangout. Later, the building was purchased by friends Joseph Canzani (a former chef at Velleggia's) and Sabatino Luperini, Italian immigrants who pulled together their resources to establish Sabatino's Restaurant. The then 50-seat eatery was an instant success. It was Spiro Agnew's favorite restaurant and has been visited by many celebrities, such as Frank Sinatra and Liberace. After several expansions into neighboring row houses and an increase in its seating to 450, Sabatino's remains a family-run business and one of the more popular iconic restaurants in the neighborhood.

VACCARO'S ITALIAN PASTRY SHOP (1956), husband and wife Maria and Nick Vaccaro, proprietors. This shop was established by Gioacchino Vaccaro from Palermo, Italy. "Mr. Jimmy," as he was known around the neighborhood, brought with him the recipes and the knowledge of how to make the finest Siciliano pastries Baltimore had ever seen. The same recipes and family tradition continue still in this *pasticceria.*

Keeping with the history of Little Italy's original melting pot status, there have been non-Italian restaurants that have opened and closed over the decades, including Persian, Indian, Spanish, Chinese and Argentinean cuisine. As of this writing, Little Italy also houses these establishments: Affogato Café & Gelato, By Degrees Café, Café Gia, Heavy Seas Alehouse, Isabella's Brick Oven Pizza, Joe Benny's Focacceria, Mo's Crab & Pasta Factory, Mo's Fisherman's Wharf, Mustang Alley's Bar/Bowling/Bistro, My Thai, Osteria da Amedeo Wine Bar, Ozra Restaurant, Palmere's Bar & Grill and Yemen Arabian Restaurant. View a complete restaurant list on promotioncenterforlittleitaly.org.

## Vaccaro-Style Tiramisu

*1 pound mascarpone cheese*
*4 tablespoons sugar*
*1 pint milk*
*espresso coffee*
*coffee liqueur*
*ladyfingers*
*cocoa powder*

Mix cheese, sugar and milk in a bowl. Set aside. Mix equal parts of coffee and liqueur in a quart-size squirt bottle. Layer the ladyfingers in the bowl or pan in which you will be serving the tiramisu. Soak them with the liquid mixture. Put one scoop of cheese mixture and flatten with a spatula to cover the ladyfingers. Add second layer of ladyfingers and lightly embed them into the cream. Soak again with the liquid mixture. Apply two more scoops of cheese mixture and smooth out with spatula. Dust the finished tiramisu with cocoa powder to hide the cream. Let stand in refrigerator overnight.

# BUSINESS BLURBS

*We're all staying right here in this neighborhood, putting our money into it and taking our profits out of it. We like it here, and we're staying here.*
*—Lou Pizza*

Different eras dictate different needs. New inventions and technology replace services previously done by hand. Machinery even replaces employees. At one time, peddlers walked or steered horse-drawn wagons through Little Italy's streets, but those services are no longer required or in existence. Gone are the coal man, iceman, milkman, bread maker, hurdy-gurdy player and the midwife. The roving grinder, with a rig strapped to his back, announced his presence to residents with a tingle of a bell. A foot pedal turned the wheel as he fixed umbrellas and sharpened knives and scissors.

Births usually took place at home. At that time, medical doctors respected and worked in conjunction with Mrs. Darago, a capable and professional midwife in the neighborhood. She was always ready with her leather satchel to hustle down the block to deliver a new *bambino*.

Neighborhood blocks held lumberyards, a pottery manufacturer, a flour mill, a naval store, a cotton broker, a novelty manufacturer, a can company, a junk dealer and even a *modiste* named Madam Barton, who designed fashionable

Residents like Rosa Quintiliani (right, with unidentified neighbors) bought everything they needed right in Little Italy from merchants once lining and peddling on the streets. *Courtesy family of Rose Quintilian Strollo.*

dresses and hats for women. There were taverns, boardinghouses, tailors, cobblers, the postal service, poolrooms, lunchrooms, drugstores, confectioneries and bathhouses. Banana and watermelon boats were nearby on the docks.

The formstone houses, many with a side "tunnel" that leads to a petite backyard, have been transformed over and over and over by immigrant merchants and subsequent generations, who opened and closed and started and stopped countless businesses to feed their families while serving necessities of daily life for fellow neighbors.

Bring up the topic with baby boomers and beyond about one corner store in the neighborhood, and you'll hear a generation reaching back to share a medley of childhood memories that elicits favorite sights, smells and tastes of their youth: fresh baked bread they could smell from blocks away at Marinelli's and DeNittis; ice cream parlors like Babe's on High Street; Vera Giancristofaro's grocery store and lunch counter across from School No. 2; coddies on crackers at Lolli's, Miss Vera's and Sergi's; snowballs available from the Meadows, Jake's and Calvo's; and more.

Calvo's opened in 1926 on High and Fawn and then moved to a larger space at High and Trinity in 1948; it offered groceries, linens, dresses, shoes, threads and more. "My mom, Mary Calvo, had most anything you needed at her store," said Sarah Ann Calvo Cicone. It was sold in about 1970.

"And the best part of being a kid in the neighborhood," said Carmen Strollo, "was chocolate-covered huge sticky apples by Mr. Marini, with the top flap so gooey and big that we used to fight over who got the biggest apple!"

Dozens of commercial names, stores and trades could be mentioned, and we'd still not cover the lengthy list of businesses that Italian immigrants began along the sidewalks. Following is a fractional spotlight of establishments that many remember fondly.

## Apicella's Grocery

*I had fun when we reopened the store and was proud when Pop came to see our Grand Opening, but nothing was ever like it was back when he and Jerry ran it. Those were the days! I miss it every day.*

—*Stephanie Hunt Greco*

Neighborhood resident Mary Ann (Boggio) Alcaraz said that she still can't find veal cutlets like Apicella's once had. "Best veal cutlet in town." She should know—she's been shopping around the neighborhood her entire life, having been born in 1938 in the same Little Italy house in which she still lives.

Opening day in 1949 of Apicella's butcher shop and grocery store, established by Alfonse Apicella (in striped shirt). The store was closed in 1985. *Courtesy Apicella family.*

Although Mary Ann had to walk only two blocks for her favorite veal, Apicella's attracted customers from as far away as Richmond, Virginia. Customers once lined up on Saturdays to buy fresh ground beef and homemade Italian sausage, mozzarella and green olives with celery. For residents, the store also served as a meeting place. "The freshest Genoa salami and Italian bread this side of the Atlantic!" remembered Jennifer Di Folco.

Established in March 1949 by Eleanor (Lancelotta) and Alphonse "Al" Apicella, son of immigrant Anthony Apicella, the store operated for more than thirty years. (Previously, it was Vaccarino's Grocery, opened in 1919 by Isadore and Rose Vaccarino.) The Apicellas had seven children: Rosemarie, Vera, Noreen, JoAnne, Carole, Jerry and Toni, all of whom worked at the store at some point, as did some of their children. Al also had three brothers: Louis, Pompi and Anthony. Several family members still live in Little Italy, such as Rosie Apicella (Louie's spouse) and Mary Apicella (Anthony's spouse).

Strolling in past the metal vintage Coca-Cola sign and under the striped white and green metal awning, customers found fresh custom-cut meats, deli options, vegetables, Italian groceries and lots of pasta, tightly packed in a one-room corner store at 221 South High Street at Stiles (now Isabella's Brick Oven Pizza).

"Mr. Al's was quite a unique store," said Carmen Strollo. "I used to remember that Joe Lopresti cut meat there sometimes, which was unusual since he had the shop up the street. Personally cut lunchmeats, overhead bins at the cash register. If you were smart, you didn't have to leave the neighborhood for anything."

"Don't forget Mr. Mike Flameni," said Carole Apicella Miller. "He worked with Dad for many years. Then there was Frank Glorioso. Mr. Frank helped my mom keep the store going when Dad had his accident and was laid up for many, many months. I don't know who was funnier, Daddy or Mr. Mike!"

Jerry took over the business in 1985, and it stayed in the family until he sold it thirteen years later. "Business wasn't what it used to be," said Stephanie Hunt Greco, a granddaughter of Al and Eleanor. "Too many would shop at the big-box stores."

The store obviously held nostalgic significance for Stephanie, enough that she and her husband, Dominick, reopened it in 2000 as Apicella's Osteria, a brick oven pizza and sub shop. "We sold gourmet groceries and Italian lunchmeats," she said. "We also brought back Pop's sausage and Grandmom's fresh mozzarella. I'm always grateful for the dedicated work ethic instilled in me by Pop and Uncle Jerry. Tons of great memories… sawdust on the floor, the notebook my grandmother kept to write down customer credits, the poster in the back with the baby pigs named after the

kids, Mr. Tony Mingioni, Pop and Jerry's jokes and every brand of cigarette every old man ordered!"

"My parents truly were two very generous people," said Carole. "They loved and were very proud of their Little Italy."

## Della Noce Funeral Home

*To others, living in a funeral home was strange, but living there was home for me. I will always remember our closeknit Italian family, neighbors we actually knew, the feeling of belonging, and safety in the "neighborhood." When people ask me where I'm from, the answer will always be Little Italy.*

*—Dolly Della Noce Bekowitz*

The 1860 building's lore tells of a first kiss among the coffins, wild card games, kids playing hide-and-seek in the caskets, a mysterious safe in the basement and a Christian mission. The latter was part of the Prima Chiesa Methodist Episcopal Italiana at 322 South High Street (corner of Trinity). When a minister from Italy, Reverend Francesco Guglielmi, saw a need for a Protestant Italian congregation in Little Italy, he began one. The building served as his residence as well. To attract people to attend services, he handed out free bread. During the Depression, the church enjoyed a brief popularity, but by 1940, attendance had dwindled and it closed.

Frank Della Noce immigrated to the United States in 1911 from Penna Sant'Andrea in Teramo, Abruzzi, at age seventeen. In 1913, he helped to organize the first chapter of Order Sons of Italy in Baltimore, the Guglielmo Marconi Lodge, so immigrants who could not speak English could band together. Married to Vittoria Grue, also of Teramo, the couple had worked together in a Baltimore tailor's shop until 1930. They had one son, Jerome.

In 1934, Frank became a funeral director; he bought the property in 1940 after the church closed and converted it into a funeral home. He had previously opened Baltimore's first Italian funeral establishment at Pratt and High Streets (later site of Velleggia's). Known around the Italian community for his charitable work, Frank offered free funeral service for anyone who could not afford to pay. "The church lay vacant a good [long time] before it was a funeral home," said Mary Ann Campanella, who lives across the street and grew up in the neighborhood. "We had a ball playing in the coffins with the Della Noce kids. Jumped coffin to coffin. They were comfy."

The Della Noce Funeral Home was popular in the gypsy community for handling funeral arrangements since the gypsies were often turned away from other establishments. They trusted Della Noce with the valuables they placed inside the caskets: jewels, utensils and money—items they believed a person would need in a next life. According to Regina "Dolly" Della Noce Bekowitz, one gypsy family had gifted a mink coat to her mother, Genevieve Della Noce (daughter-in-law of Frank and Vittoria).

The gypsies commonly dressed to the nines to attend viewings, where they drank, ate and played music. Dolly said their favorite song to play, while leading the casket out of the funeral home, was the theme from *The Godfather.* "That funeral home née church/mission, née town houses, has a pretty intriguing history…gypsy funerals and all. Colorful!" said homeowner Barbara Stone.

Eventually, the family funeral business was taken over by Jerome and his wife, Genevieve, and beginning in the 1970s, they were assisted by their sons, Frank II and Jerome (Butchie). In addition to Dolly, two more sisters, Geraldine and Francine, rounded out the family. All were involved in the business one way or another, especially because the phone needed to be answered around the clock. "As kids, we were only allowed to tiptoe and talk softly when there was a viewing," said Dolly, sixty-nine, "or my grandfather would come upstairs and raise holy hell." Later, the family grew so large that the two generations would use the funeral parlor's large room on the first level to exchange Christmas gifts.

After Jerome's death in 1985, mother and son (Frank and Genevieve) took over, assisted by Butchie. Frank became sole proprietor in 1995 after Genevieve died and ran it until the handsome property was sold (circa 2003) to a developer, with its interior transformed once again. Currently as two townhomes with added garages and rooftop decks, the entrances and address were modified to Trinity Street.

The well-maintained building has retained its stained-glass windows (from Germany) and Flemish bond brickwork. The design of the side door at the corner of High and Trinity still resembles that of a church. "An old safe sitting in the basement boiler room seems to hold fascination with the Della Noce family," said Stone. "Several family members have stopped by to see the house, and the first thing they asked was, 'Can I see the basement?' Who knows what stories it holds with the colorful history of the Italian immigrants? And I've heard about the raucous card games played here."

Dolly mentioned that the original building was built around that safe. "There is no way to get it out," she said. "It's tremendous! I don't think we ever got it opened to learn what's inside."

Willy Sydnor was a friend of Dolly's and occasionally, in the early 1970s, would accompany her to lunch in the family's home above the funeral parlor. "There was always a huge pot of soup on the stove," said Willy. "Grandfather Frank, with a glass of homemade wine, would be sitting at the kitchen table. He spoke little English and I spoke less Italian, but we'd make our thoughts known. Family members would translate if necessary. I remember on at least one occasion we went downstairs to ask [her father] about something, and he was working on a body. Dolly would caution me to stay back even though she was used to the everyday goings-on of the business."

## Jake's

*Great people, Jake and Miss Anne. After school we would play Pinochle with Jake. He could never beat us.*

*—Johnny Manna*

The well-loved Jake and Anne Gentile operated a busy corner store at Stiles and Exeter Streets, opposite Saint Leo's Church. It was stuffed with a variety of useful daily merchandise and sweet goodies—even single cigarettes with a match. "Miss Anne" was usually out front waiting on customers or back in the kitchen. Usually busy puffing a pipe or cigar, Jake helped his wife after returning home from his full-time job at National Brewing Company.

Before joining their friends to play in the streets, kids would pop in and out of the corner hangout to buy Tastykakes, candy, bats, rubber balls, snowballs and "coddies" (codfish cakes) on saltine crackers. "When we had recess at Saint Leo's School," said Deborah DiFolco, "we ran to Jake's for a snowball with ice cream at the bottom and marshmallow on top. That old stainless steel ice machine was so big."

Out of the four Gentile children—Joanne, Vince, Jimmy and Arthur— the last of the bunch still resides in the house, its old metal screen door covering a front door still stickered with faded ads, such as one for Abbotts Ice Cream. They closed the store about a quarter of a century ago after Jake died in 1986. "We didn't want Mom to have to handle it alone," said

Carmen Strollo, Jake Gentile and Arthur Gentile by the back door of Jake's store, circa early 1960s. *Courtesy family of Rose Quintilian Strollo.*

Arthur about Anne, who lived until 2012; she was a regular Saint Leo's Church volunteer.

In a 1977 *Piccolo* newsletter, Tony DeSales eloquently wrote, "It had never been easy for Anne, once Jake had been hurt badly in an accident on Albemarle Street. It was less easy when he was taken ill again. But in her eyes is yet a smile that comes from determined courage. Her children are grown, well-raised, educated and productive citizens. The strong become only stronger when the burden grows heavier. The Gentiles are among our neighbors."

## Kelly & Poggi's Italian Pharmacy

*I remember buying Malo cups, chocolate with white cream inside. The store had a nice variety of candies and baseball cards with gum. I also took piano lessons from Miss Julia. Boy, you had better be prepared for your lesson, or she would not be happy and let you know it!*

*–Anthony Ferrari*

As a teenager, Gabriel "Gabe" Poggi (born in 1873) helped Dr. Thomas Kelly compound prescriptions in the doctor's apothecary shop, and he fell in love with the profession. Founded in 1860, the pharmacist added the Poggi name as Kelly and Poggi formed a lifelong friendship. As Dr. Kelly became feeble, Gabe and his new bride, Elizabeth Galli Poggi, moved into the property in about 1913 and took over. "I wouldn't want anybody else to have it but you," Dr. Kelly told him. "You are just the finest man that I could ever find…but I would like if you continued to use my name."

"It was a beautiful friendship," said daughter Julia Poggi (born in 1909) in a 1979 BNHP interview about the two pharmacists. She and her siblings, Mary and Gabriel, grew up in the store, where they lived above with their family. "They did a fabulous business in those days. The older Italians referred to [my father] as *professore*. They came with all their problems, regardless what their problems were—big, small, in-between. And they always came to him first before they would go to a doctor. They relied on whatever he would tell them…here my father was the pharmacist, he was the psychiatrist, he was everything."

Once Gabe even concocted a "love potion" for a neighbor, John, who desired to win the heart of a girl named Rose. Nothing but sugar water, the mixture nonetheless seemed to give John the confidence to ask out the girl he was madly in love with, and "don't you know he married her," said Julia.

Gabe waited on Italians with varying dialects; he served ship chandlers and captains of French and Italian boats coming into the nearby harbor. "We got a lot of Italian prescriptions right from Italy that were mailed out here to be filled and then sent back. Our sign always read…'Italian Pharmacy—Kelly & Poggi.'"

The pharmacist would oblige families as they requested antiquated remedies such as camomile, laurel leaves, fennel seed tea, santolina and oil of santyl and asked the pharmacist to cure their babies who "got the evil eye and…caused the child to have worms" (so they thought). The shop also sold leeches, once used to cure infections and assist therapeutically. "We had a very big prescription room and…quite a big cupboard…people would come to the store and they'd say 'give me five cents worth of Epsom salts, five cents worth of bicarbonate of soda'…and various others."

Mr. Poggi wrote his secret code "p.p." (poor people) on some prescriptions after doctors dropped them off. The kind and well-respected pharmacist dispensed medicine to those folks at no cost. He also kept a ledger book for people who bought on credit. "It was amazing the people who could really afford to pay their bill," said Julia. "And the real poor ones would come and stack pennies in tens. And many days I was in the store with my father, and he would say, 'Tony, I'm not after you to pay your bill because I think that your children need food on their table. Take your money and go.'"

At times, he would work well into the night, knowing that the local doctors, such as Dr. DiMarco, were making night house calls and would be bringing back prescriptions to fill. "Dr. DiMarco and his son took out my tonsils at age three on our family kitchen table," said Gary Molino. "It is my earliest memory."

Gabe was considered one of the top pharmacists in the city. "My father got up at any hour of the night," said Julia. He had placed a big bell in his bedroom, and "when that thing went off, everybody jumped out of bed at once because it sounded like a fire bell. Once there was a knock, my father put on his bedroom slippers and a heavy robe; Mom was always by his side. A beautiful life, I must say," said Julia, who studied pharmacy for a short while. Her brother Gabriel "Doc" Poggi worked in Dr. Albrecht's store in Glen Burnie.

The 241 South Exeter Street storefront sat across from Mugs' corner and Pepino's Tavern at the corner of Fawn Street. After Gabe died and two other pharmacists worked there until their deaths, it ceased to be as a pharmacy. Spinster sisters Julia and Mary then transformed their father's shop into a soda fountain and card shop with the legendary standup scale by the door.

They knew everyone by name—a scene right out of Mayberry, said Carmen Strollo. "They made you feel right at home like you were family. But they were as professional as they come when it came to the business." "They had everything you needed that wasn't groceries," remembered Lisa Gray VandeGiessen. "That was the only place where I could get a phosphate soda. Penny candy. Medicine for whatever ails you."

Debbie Schwabline remembered the piano lessons given by Miss Julia in the basement. Going into the store as a kid, she said, "We had to show them our hands to make sure they were clean, or we could not touch anything."

Former Little Italy resident Ray Alcaraz was about twelve years old when he became a delivery boy for Kelly & Poggi when it still sold prescription medicines—he made twenty-five cents per delivery. In 1995, he leased the storefront to try to revive it as a corner convenience store with soda fountain service, sundry items, cards and coffee, but he closed it after two

years. "People didn't want a corner store anymore," said Ray. "They wanted the mall. I bought the place more out of emotion than anything. That neighborhood means so much to me."

## Pastore's

*Working as a teenager with my family, I remember every Sunday the grocery store was open from 7:00 a.m. until 3:00 p.m., our busiest day of the week. When the Saint Leo's and Saint Vincent's Masses were over, people would stop in before they went home to prepare Sunday dinner. My grandparents lived upstairs from the store; when it closed, the whole family would get together and eat the Italian meal, which my grandmother had prepared. It was our Sunday ritual—eating, talking and sometimes singing! How I enjoyed and miss those days in the 1960s.*

*—Michael Pastore*

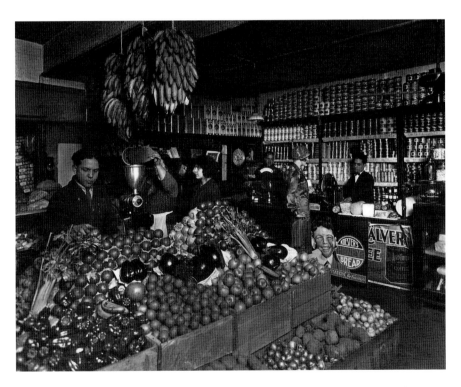

Pastore's store, once on Lombard Street, sat amid mostly Jewish merchants, 1926. *Courtesy Michael Pastore.*

The Pastore business had its humble beginnings as a confectionery store near Little Italy at 1007 East Lombard Street amid the heavily populated Jewish merchants. Vincent Garafalo of Palermo, Sicily, was an Italian sculptor who opened the store circa 1898 with his wife, Cira, during the large influx of Italians to Baltimore. The couple retired in 1935, at which time they divided the business between two daughters and sons-in-law: Mary and Frank Pastore took over the grocery component, and Rose and Tony Giammona took over the produce and fruit.

The business was further divided in 1968 between Pastore brothers Vince (retail) and Mike (wholesale), the latter setting up his warehouse in 1975 at Pratt and Albemarle Streets (today it houses Toscana Medispa, Hertz and a parking garage). From Joseph Vaccarino, Mike and his son, Michael Frank Pastore, bought the *Sole d'Italia* (Sun of Italy) brand name and warehouse (former synagogue at Stiles and High) and expanded the Italian food tomato-based product line into more than one hundred assorted products.

Today in its fifth generation of operation, Sun of Italy is operated by Michael Frank Pastore and his son, Michael Joseph Pastore II, at 6101 East Lombard Street and has been for the past twenty-five years. Pastore's retail stores are located on Philadelphia Road (operated by Frank Pastore, Vince's son) and on Loch Raven Boulevard at Joppa Road (operated by Frank's brother, Vince).

With seven young grandchildren, Michael Pastore feels confident that there will be a sixth generation to carry on the Pastore name and the Sun of Italy line of Italian products.

## *Public Bathhouse*

*Things change. That's just the way it is.*

−*Tom Scilipoti*

At 131–133 South High Street, the popular and clean Walters Public Bathhouse No. 1, an instant success, was the first to turn on its faucets in 1900. Funded by Henry Walters, a Baltimore philanthropist, he paid for three other facilities as well. The city operated six public bathhouses in all and charged folks a nickel for a towel, a small bar of soap, a cardboard comb and, best of all, a five-minute hot shower. If kids grouped together in threes, they were allowed in gratis. Some people didn't pay at all, appealing to the attendant's mercy when admitting they couldn't afford

the fee. The man or lady "at the window" took them for their word. If your time ran over, "they rapped on the door to tell you to get out," said the late Tony Giorgilli.

Bathhouses existed since there was little indoor plumbing; few Baltimore homes had indoor toilets, tubs and showers—and if they did, there was no hot water. Using it was considered a luxury, especially in the Depression era. "That was the best bathhouse there was," said Louise Gulieri Snyder in a 1996 *Baltimore Sun* story. "It was spotlessly clean. The water was hot."

Nearby neighbors even used the steam spilling out of the bathhouse to help dry their laundry hung outdoors. Angie Molino used to tell this story to her kids when she reminisced about the bathhouse in 1942: "I was on my way to the bathhouse on my wedding day with no makeup and old clothes, when a neighbor saw me and asked if I was going to be ready in time. I told her to see me in an hour and that I would be beautiful."

After serving a staggering 8.7 million bathers in its time, the bathhouse was torn down in 1954 to make room for the appealed Flag House Court housing project.

## Sergi's Ice House and Restaurant

*I can remember Mom and I opening up the coffee shop every morning while I was attending Calvert Hall. I would make the coffee in the morning and wait for the baker and doughnut man.*

*—John Kidwell*

The horse was too big for seven-year-old John Sergi, so his father, Antonio, would help him up onto the wagon before getting the animal out of the stable. In the early morning before school started, the boy "fed the horse and put the harness and things on him, and got him ready for work," said John (born in 1928) in a 1979 BNHP interview. "And then when my dad was ready, he helped me on, and got the horse out...he got our ice and we started delivering."

Number 248 Albemarle Street (now the site of La Tavola Ristorante Italiano) was a backbreaking icehouse business called Sergi's Ice House (1911–1955); the only icehouse in the neighborhood, it served Little Italy and the surrounding communities. It was founded by Mary (Fidi) and Antonio Sergi, who immigrated to the States in 1904 from Messina, Sicily, and eventually relocated to Baltimore, where they made and sold ricotta and

milk at 244 Albemarle Street (the first house they bought). They delivered it by horse and wagon, said their daughter, Jean Sergi Kidwell (born in 1918), before beginning the cool summer business of selling ice.

It seemed convenient that the couple had had so many children—all the extra hands came in handy, as the business "grew so big," said Jean. "I had seven brothers all in business with my father." At the time with the honorary title of "Largest Family in Little Italy and Baltimore City," the Sergis bore twenty-one children; only fourteen survived—seven boys and seven girls. Some died at birth and others from the diphtheria epidemic. Jean was the eighteenth child; she and her sister, Antoinette, ninety-two, are the only ones still living.

John Kidwell, seventy-three, relayed a comical story told by his uncles to indicate the large size of the family: "They all had sat down for Sunday dinner. A man had come in and left after he finished eating. My grandfather looked at my Uncle Joe and asked, 'Who was your friend?' to which Joe replied, 'He wasn't my friend. Maybe it was Dominic's.' Grandfather looked at his other son, 'Dom, who's your friend?' to which Dominic replied, 'That wasn't my friend either.' Turns out a complete stranger had walked in and eaten with the family! It was always such an open house. Even the neighbor Matricianni boys would rather go over and eat there instead of their own house."

For Antonio and his seven sons, it was laborious and tedious to haul ice blocks up the stairs in the heat of the summer and carry bundles of wood and kerosene oil in the cold of winter. Many times it was necessary to trek to the third floor to place ice in an icebox or dump wood near a potbelly stove. That came *after* they had hand cut trees in the country and hauled the wood back to Little Italy. "We sold five- and ten-cent pieces [of ice] since people could not afford too much in those days," said John Sergi. "We had a whole lot of headaches and heartaches…tell your father I'll pay him Saturday; and Saturday never came. My dad lost a lot of money, but he didn't care. He was a good-hearted man. He helped out anybody."

Antonio bought his first truck of three (with "Anthony Sergi & Sons" signs on the doors) in 1944 to begin replacing the horse-and-wagon method of ice delivery. "Dad bought another and another and then [got] rid of the horses," said John. As refrigerators became more affordable and mass-produced, it was the end of the line for icemen.

Sometime after her parents' business had ceased, Jean operated Jean's Coffee Shop in the front of the house while living there and taking care of her mother. An older brother, Benny, was her partner. In 1970, she established Sergi's Ice House Restaurant with its antique ice tongs, hatchet,

ice pick and ice shaver hung on its walls in honor of her father's business. "It was a pleasure to do all of this," said Jean, "a beautiful experience. I felt my father was looking down with approval with what I did the property."

In the kitchen, Jean and one of her sons, Eugene Kidwell, prepared Sicilian-style recipes (claiming to be the only restaurant in Little Italy to offer Sicilian food) and made pasta by hand—ravioli, gnocchi, lasagna and fettuccine. Her other son, John, bartended.

When her sister Grace died, Jean closed the restaurant in 1984 after having made a solemn promise to care for Grace's three young children, as two had been born with cerebral palsy. The property was sold, and Casa Pepe was opened, the first Spanish/Italian restaurant to open in Little Italy.

At almost ninety-seven, Jean still resides in the neighborhood on the same block where Sergi's Ice House existed—a neighborhood she says is "still a lovely place and the safest in the city. Thank God we still have a good neighborhood. There are still quite a few Italians in Little Italy. But so many of our lovely neighbors have gone, so many. When I sit out here on the bench, used to be everyone was sitting out. Now I'm the only one."

## Sudano Produce

*My father was like mayor down here.*

*—Charlie Sudano*

Inside 302 South High Street, a midwife had delivered ten Sudano children—five boys and five girls—offspring of Sebastiano "Benny" Sudano and the bride he married in 1922, Cicamina "Regina" Impallaria. Benny, also nicknamed "Graveyard," was an immigrant from Catania, Sicily; his wife was born in the United States. Only three of the ten children are still living: the baby, Charlie "Bananas" Sudano, seventy-two, and two of his sisters, Josie, seventy-nine, and Mary, eighty-eight. Charlie and Mary reside together in Little Italy.

The Sudanos initially operated a poolroom in front of that house. In about 1932, the last year of Prohibition, Benny and his brothers established Sudano Produce to offer fruit and produce to restaurants and small grocers in the area. Since they knew fruit and they knew *vino*, they added wine grapes to their inventory to sell to those who produced homemade wine. Benny arranged for truckloads of grapes to be shipped from California—grapes that would appeal to the Italian's palate such as Zinfandel, Alicane, Muscat and Carignane.

That segment of the business grew as sound as the produce side; by 1960, the company was ordering 216 tons of grapes, which then arrived by train. Sons Benjamin and Joseph worked alongside their father before taking over the business in the 1950s. Since 1985, their sons, Benny and Brian Sudano, have operated this third-generation company as S&S Winegrapes & Equipment Company, based in Jessup and still catering to the home winemaker. "It was our family business," said Ben in a 2002 *Baltimore Sun* story, "but it was also a way of life." Like their customers, the Sudano cousins choose their preferred grapes; like their fathers and grandfathers, they make homemade wine.

S&S also retails winemaking equipment, including barrels, grape presses, crushers and cork finish bottles. The boys have indeed inherited their love of wine and winemaking from a man who once sat in the evenings conversing on the steps of Little Italy row homes drinking (what else?) wine with *amici*.

# Chapter 10
# *Tales and Tidbits*

*The day after I graduated from high school, I went to work for an Italian contractor, Matricianni. When Nancy and I were going to get married, I said, "Boss, I'm gonna get married." The first words out of his mouth were, "Is she an Italian girl?"*

—*Anthony Azzaro*

President Lincoln's assassin, John Wilkes Booth, was raised on Exeter Street a few blocks north of Little Italy in the 1840s. He and his two brothers later became actors, first performing as amateurs on a stage they had erected in their backyard.

---

In September 1781, during the American Revolution, an army camped at Exeter Street and Eastern Avenue on its way to Yorktown, Virginia. Local historian Rob Reyes said that they obtained fresh water with which to cook and wash clothes from Harford Run, which ran along today's Central Avenue. The camp was one thousand strong—a German regiment called Royal Du Pont under the king of France.

---

Edgar Allan Poe once lived in Mechanics Row, as Little Italy was once called, on Wilkes Street (now Eastern Avenue) in a house that has since been demolished.

———

One of the most widely remembered nuns to serve Saint Leo's was Sister Radegundis, the cook for the convent during the worst years of the Depression. She had a little white dog named Buddy that acted as the school's "truant officer." If some of the children were late, he would bark continuously until the Mother Superior would go outside and catch them.

———

Some streets in Little Italy are reminiscent names of London town, the origin of many of its first dwellers—for example, Stiles, Exeter and Albemarle Streets. On the corner of President Street and Eastern Avenue, Emilio Morisi owned a hotel. In a 1926 *Baltimore Sun* story, the red brick structure was named then as more than a century old and was "headquarters" for men traveling as entertainers and troubadours—those with trained bears, dogs, monkeys and parrots.

———

In the summer of 1979, President Jimmy Carter stopped in Little Italy while touring Baltimore. He and his entourage ate lunch at Chiapparelli's and visited the D'Alesandro family and Saint Leo's. Little Italy enjoyed national attention as a result of the visit.

———

More than a few politicians have come out of Little Italy, including Vincent Palmisano (House of Delegates, 1914, and city council, 1915; first Italian-born member of the U.S. House of Representatives, 1926); Thomas J. D'Alesandro Jr. (state legislature, U.S. House of Representatives, three terms as mayor of Baltimore); Thomas D'Alesandro III (mayor of Baltimore); Congresswoman Nancy D'Alesandro Pelosi (Democratic Leader of the U.S. House of Representatives); Joe Milano, Nicholas Bruno, Joseph Cherigo and Joseph Bertorelli all served in the House of Delegates; John Pica, Sr. served on city council.

———

Various neighborhood associations sprang up to gain attention in local media as issues around the parish, school and neighborhood arose, such as the closing of the school and the extension of Interstate 83 in the early 1960s. With a common mission of helping to preserve and improve the neighborhood, the Little Italy Community Organization (LICO) and the Little Italy Restaurant Association (LIRA) formed in 1972. The Little Italy Lodge was active in the efforts as well. The Original LIRA, as it is now called, currently has only four restaurant members; however, it packs a punch in the neighborhood as annual host of the popular and well-attended Open Air Film Fest (since 1999). Newer organizations include the Promotion Center for Little Italy, Baltimore (2010; the author is its director) and the Little Italy Property Owners Association (LIPOA, 2012).

———

The Monaldi family has been making music since 1948, when Olindo Monaldi arrived in America from Pesaro, Italy, with three dollars and a trumpet. Later, he taught himself to play left-handed after losing three fingers on his right hand in a diving accident. Once in Baltimore, he took a job at the original Maria's 300 Restaurant as a dishwasher and, later, a cook. There he met and eventually married Maria Vidi, a pretty Italian waitress. In Little Italy, the couple raised five sons and two daughters. Olindo continued with his love of music and passed along the passion to his sons Pete (accordion), Joe (trumpet), Frank (drums), Olindo (bass guitar) and Mario (saxophone) as they each became of age. As the Monaldi Brothers, they gained widespread fame and popularity, performing at weddings, dances and various events within the Italian community and throughout the region. Olindo died in 1987, but his musical legacy lives on through the talents of his children, grandchildren and great-grandchildren. Mixed Company, featuring several of the Monaldis, is a fixture on stage during the neighborhood's Italian festivals.

# Chapter 11

# *Modern Little Italy*

## ROMEO (Retired Old Men Eating Out)

*Nothing about it is the same. When I was young, Little Italy existed because of the people who lived here. Now it's all restaurants. I'd walk around the neighborhood, and whether they knew your name or not, they would know you.*

*—Ron Sapia*

There were nicknames like Fookie, Bananas, Jello, Bobo and Beaners. There was Joe Bags, Dosher, Crowfoot, Turtle and Nick the Greek. There was Mazzie, Champ, Corky, Eight Ball and Meatball, as well as some guys without nicknames. They were the corner guys, the neighborhood gangs, several generations of the "boys" of Little Italy. Some are long gone, and some are still around. Most got married in their day and moved out.

Charlie "Bananas" Sudano did neither—he's still a bachelor and still lives on High Street. A decade ago, he began organizing a monthly gathering of ROMEO (Retired Old Men Eating Out). Now grown men, the boys convene on the second Tuesday of the month to eat, drink, call each other "jerk" (and worse), use Italian slang and reminisce about growing up in the neighborhood, while they hoot, howl and hug over all of it. Guys in their '50s, '60s and '70s with two things in common—nicknames and their fondness for "The Neighborhood." Most are Italian, and some are Irish and

Neighborhood boys (in front of Luge's Confectionery, now Sabatino's) bestowed comical and witty nicknames on one another such as Squawker, Popeye, Musher, Skizzy, Bowlegs, Lightning, Shorty, Lunchmeat, Bumfin and many others. *Courtesy Thomas C. Scilipoti.*

Jewish, just like it was as they were growing up on the various blocks of the neighborhood. They were tight.

"If we had $10…you had $10," said Charlie. "That's the way we grew up. I just started to get them together, and guys started coming. We love each other. But we tell it like it is."

It could be fifteen of them who show on a given night or it could be thirty. The venues change around the Little Italy restaurants; sometimes the group ventures to other parts of Baltimore to eat at other Italian restaurants. "Some guys have changed a lot, and some haven't changed at all," said a regular attendee, Gary Molino, sixty-nine, who somehow escaped earning a nickname that stuck as he grew up at 410 South Eden Street. There weren't many Garys, so perhaps he didn't need a nickname, but mention "Tony" and no one knew who you were talking about. "The next sentence would be, 'Which Tony?'"

His brother, "Johnny Wayne" Molino, also attends ROMEO and says, "It gives me a sense of what we all shared. I always learn something new about neighborhood lore." The brothers' childhood buddy, Frank "Fookey" DiAngelo, lived at 509 Albemarle Street. "I spent many summer days at 410 Eden Street trading comic books with John and Gary," said Frank, "and

145

playing all kinds of games in the attic. Great memories. I still remember my phone number—Lexington 9-5561—ha! It's great to see the guys and reminisce of the special times we had growing up together in a unique neighborhood. It is also interesting to see where life has taken each one of us, including both the ups and the downs of it all."

The trio attended Saint Leo's School in graduating classes of 1958 and 1960. Frank was an altar boy. Gary couldn't handle the smell of the incense, he admitted. He was the only boy to not stand up when a nun asked, "Who wants to be an altar boy?"

Charlie Bananas admitted that he doesn't even know some of the guys' actual first names. "I didn't know Jello's first name [Frank] until we started meeting for the dinners," he said. "We just know each other by nicknames." So, how was he nicknamed "Bananas"? In the produce business, his father, Benny Sudano (see the subsection "Sudano Produce"), stored bananas in their basement to yellow. In the 1950s, as Charlie was hauling banana bunches out of the cellar, some guys were walking by and said, "Hey, Charlie Bananas!" and that's how easily the name stuck. Now's he's a seventy-two-year-old man still answering to his childhood nickname.

Well, boys will be boys, and they will be named Chubbers, Jeep, Mustard, Dithers, Buster, Chippy, Lunchmeat, Piggy, Sonny, Zeke, Bowlegs…

# An Era Erased

*The people in Little Italy have heard many times the dreary list of reasons why their neighborhood and its traditions cannot survive. They have a way of listening, agreeing, shrugging their shoulders. Then they draw on some deep and hidden mystic force and keep going just as they always have. They will give up nothing*
*—author Gilbert Sandler, 1974*

Nothing stays the same—*niente*. Our existence involves ebbs and flows, progression and setbacks, night and day. Transformation of all things and people on our earth is a natural occurrence in the circle of life.

Little Italy has altered radically in a century and a half. What hasn't? Most will say in their "Baltimorese" that the neighborhood "ain't what it used to be," although there are still a few constants: Italian residents (percentage unknown), processions of religious statues, folks' attachment to Saint Leo's Church (continuing as the pulse of the neighborhood), the aroma of Italian food wafting

through the air, the game of bocce, an occasional song on Vince Piscopo's accordion and Vito Iacovelli's and Marco De Simone's mandolins and, undoubtedly, Italian pride, a fixed trait surely never to change among Baltimore's Italian community.

Yet none of these scenarios is what it once was, and anyone old enough to remember decades back will tell you so. *But Little Italy has survived.* It is intact, its original boundaries altered very little—its twenty-plus blocks nestled between the Inner Harbor, Fells Point, Jonestown and the newest of city neighborhoods, Harbor East.

"Even though we fight sometimes," said immigrant Giovanna Aquia Blattermann, sixty-six, "we also all bind together. This [Little Italy] is the mother; we all came from the same womb. We've kept it together. Little Italy is the only

Anyone who grew up in "The Neighborhood" will describe how wonderful it was to be a kid there. *Left to right*: Mike Giro, Rolando Giacomelli, Sam Giro, Anthony Meo and Carmelo Meo, circa 1946. *Courtesy Denise Giacomelli Loehr.*

neighborhood that has retained its ethnicity, longevity and dimensions in all of Baltimore's neighborhoods."

Blattermann arrived from Cefalu, Sicily, in 1953 at age six with her mother, Rosa, ninety (still a resident); her father, the late Pasquale "Charlie" Aquia; and her brother Salvatore (Sammy). "At a time when no one liked to move around," Giovanna tells people, "our family traveled 3,500 miles and we haven't moved 200 feet since."

The Aquia/Blattermann family is the only immigrant family remaining in Little Italy, she said, and the only residents made up of four generations. A neighborhood activist, she and her husband, the late Albert Blattermann (born in Little Italy), raised three children there—one died at a young age. In turn, their grandchildren are being raised in the neighborhood by their daughter, Gia Daniella Blattermann, and Gianfranco Fracassetti from Bergamo, Italy.

Gianfranco is a chef at Café Gia (formerly Iggy's Sandwich King), where since 2009 the mother-daughter Gias have owned and operated this Sicilian bistro.

Little Italy has changed drastically even since little Gia, forty-one, was a child. "In today's Little Italy, you'll find a lot of young middle-class families who want to offer their children the spirit of city living in a safe, close-knit community," she said. "The neighborhood was comprised of mainly immigrant elders who moved here in their younger years. Many of my neighbors and friends were first- or second generation. We were raised in a culturally enriched community very deeply connected to our heritage and roots."

It is impossible to ask directly of the first immigrants how has Little Italy changed, as we can reach back only so far to compare then and now and recognize the radical alterations. Even in the disparity between life, say, in the 1960s compared to 2014, drastic changes have occurred: technology, mindsets, fashion, buildings (razed or renovated), simplicities and complexities. We can offer glimpses from memoirs written, published stories and oral accounts, yet we cannot chat with the immigrants who first established the Italian neighborhood. They are gone, and along with them went their way of life.

The gridded Baltimore neighborhood is now a blend of folks, not unlike the era when Irish, German, Jews and Italians jointly inhabited it, yet dissimilar to the period when all residents' names ended in vowels and each property was passed from generation to generation. Baltimore's Italian community is sizeable, extending well beyond the streets of Little Italy. "It's different; lots of people have moved away and passed away," said Lucy Pompa. "It's a smaller group of Italians now. A lot of these houses are owned by Italians who rent out the homes."

Today's generation doesn't realize exactly how drastic the changes have been. One neighborhood description from eighty-nine-year-old immigrant Andrew Lioi provides an accurate perspective:

*The difference in Little Italy now and when I was young is sad and heartfelt. When I was young, the neighborhood was vibrant, with children playing on the streets and hanging out on the steps playing games. Adults also sat on the steps, conversing with neighbors in Italian; some played guitars and mandolins or [the game] morra. Some of the men hung out in the various bars or confectionery stores to play cards or just to congregate and converse. There were the Italian groceries stores where the cheese and bacala hung from the ceilings; baskets of snails sat on the floor. Our playing field was at the pumping station, and we would play hockey on skates on the asphalt streets. The boys played caddy or baseball*

*in the streets, while the girls played jacks or pickup sticks on the marble steps. Saint Leo's School was full of children…there were more festivals than just Saint Anthony and Saint Gabriel, and thousands of people attended the processions.*

Lioi noted that there are fewer residents there who are offspring of the immigrants, and even their numbers are declining due to old age. There are no children playing in the streets, not many adults speaking Italian and no one playing music. The school has been long closed. "The wine makers are gone; the groceries and butcher shops have long been gone," continued Lioi. "There is still a Saint Anthony and a Saint Gabriel Festival, but the processions are small; few spectators witness the celebration. Little Italy today exists as a tourist attraction or for celebrating an anniversary, birthday or graduation at one of the restaurants."

Certainly physical changes happen universally—it's the natural turn of events. While things and scenarios may not last, such as coal stoves, children playing in the streets and Italian music in the air, *emotion* for a neighborhood

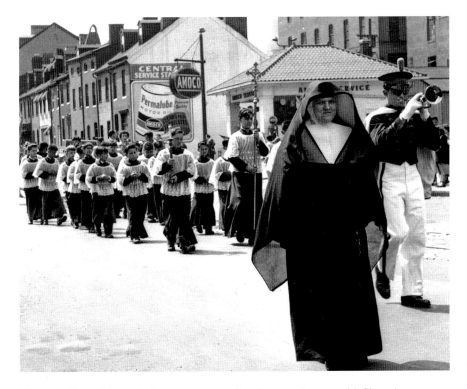

The 1949 Feast of Saint Anthony procession along Eastern Avenue, with Sister Agnes Sullivan pictured. *Photo by Thomas C. Scilipoti.*

can last forever. Many in Lioi's generation may have moved out of Little Italy, yet their dedication and love for the old neighborhood remains.

"We come to Mass at Saint Leo's Church, attend the festivals and enjoy the events," said Lioi. "Many of us belong to the Little Italy Lodge and go there for the Friday Night Dinners…it is good to go to Little Italy and see old friends that you grew up with and relive past experiences. Whenever I go back to Little Italy, I have a strong emotional feeling that I am back at home."

And yet Little Italy is the same because of the amorous allegiance held for the neighborhood by its residents and by those who have moved away. A generations-old love for the community's beloved Saint Leo's Church and its many branches, for the Little Italy Lodge and its myriad events, for the traditional game of bocce, for studying the Italian language in the learning center, for eating food "like *mamma* made" at the few dozen restaurants and, always, for *la famiglia*. In the eyes, soul and heart of an Italian, family is everything. "Don't say nothing bad about anyone because we're all related," said Lucy Pompa.

Theresa Ferraro had embraced *Piccola Italia* from age five to her current senior age, "a lifetime," she said. Does she miss it since moving to senior housing in Fells Point? "How can I miss it when I'm here all the time?" Good point. The spinster is as much a fixture in Little Italy as its historical buildings—she attends every event, Mass every Sunday, every festival and almost every Lodge Friday Night Dinner. Theresa shuffles around town, her tired legs failing her, past her former house, in and out of the church and school halls, and often parks herself on an outdoor bench, simply watching, probably remembering. Like many other Italians with heart-shaped ties to "The Neighborhood," Theresa can't break off her lifelong affair with Little Italy either.

Our ancestors brought Italy with them to America before we were specks in the womb. If they had known that their traditions would be Americanized within two generations' time, would they have still sacrificed their country, their heritage and their customs? Would they have relinquished it all for the golden American opportunity if they knew that their grandchildren and great-grandchildren wouldn't entirely embrace their ways?

For what do we offer as Italians in our modern day to keep Italy alive in our hearts? Make sauce? Serve olives? Grate *Parmigiano* cheese? Say *ciao* and *arrivederci*? Would our *nonni* be saddened to watch us live as we do? Fast food, faster cooking, screw-top wine and English only. Or were they prepared to pay the American price as they left the Old Country? Did they realize that we would be *thoroughly* Americanized?

The Neighborhood may no longer be as it was—a miniature replica of an Italian village—yet it is still Italian. And it's still there. And for that alone, our ancestors would be pleased.

# Bibliography

## Books and Programs

Baker, Paul Mugavero. *La Famiglia Americana: The American Family*. Baltimore, MD: P.M. Baker, 2002.

Begni, Ernesto. *The Catholic Church in the United States of America*. New York: Catholic Editing Company, 1914.

*Celebrating the One Hundredth Anniversary of the Saint Anthony of Padua Society of Saint Leo the Great Roman Catholic Church, 1904–2004*. Saint Anthony Society program booklet, February 8, 2004.

*The Church of Saint Leo the Great: Celebrating 120 Years of History and Heritage, 1881–2001*. Baltimore, MD: Church of Saint Leo the Great Press, 2001.

*The Church of Saint Leo the Great, 1881–1981: The Heart of Little Italy*. Baltimore, MD: Church of Saint Leo the Great Press, 1981.

French, Rita DeSales, Perrin L. French and Irvin F. Lin. *Baltimore's Own Little Italy Artist: The Artwork of Tony DeSales*. Palo Alto, CA: Genovefa Press, 2003.

Kelly, Cindy. *Outdoor Sculpture in Baltimore: A Historical Guide to Public Art*. Baltimore, MD: Johns Hopkins University Press, 2011.

Lioi, Andrew. *Rosaria's Family*. Baltimore, MD: Gateway Press Inc., 1997.

Olesker, Michael. *Front Stoops in the Fifties: Baltimore Legends Come of Age*. Baltimore, MD: Johns Hopkins University Press, 2013.

————. *Journeys to the Heart of Baltimore*. Baltimore, MD: Johns Hopkins University Press, 2001.

Pente, Angelo Pasqual. "How I Remember Little Italy: A Descriptive Rambling." Unpublished memoir, February 1991.

Povich, Elaine S. *Nancy Pelosi, a Biography*. Westport, CT: Greenwood Press, 2008.

*Saint Anthony of Padua Society Gala Banquet*. Event program, February 8, 2004.

Sandler, Gilbert. *The Neighborhood: The Story of Baltimore's Little Italy.* Baltimore, MD: Bodine & Associates Inc., 1974.

Sherwood, John. *Maryland's Vanishing Lives.* Baltimore, MD: Johns Hopkins University Press, 1994.

Sullivan, Edward M. *Genesis and History of the National Columbus Celebration Association.* Program booklet of NCCA's twenty-year history, n.d.

*Tenth Anniversary Saint Leo's Gymnasium and Literary Association.* Program booklet, January 30, 1901.

# ARTICLES

*Baltimore American.* "Affairs in the City." July 6, 1864.

DeSales, Tony. Family's collection of *Piccolo* newsletters.

*Maryland Living/Gourmet's Delight.* "Little Italy's Roma Marks 50th Year" (October 24, 1965).

Sandler, Gilbert. "Little Italy: It's Saint Leo's, Ex-Mayor Tommy, Pasta, Wine and Love of Life." *Sun* magazine (December 14, 1969).

Scalia-Levon, Rosalia. "A History of Little Italy's Restaurants." *Italian Times*, 1986.

Scarpaci, J. Vincenza. "Ambiente Italiano: Origins and Growth of Baltimore's Little Italy." *Institut International D'Histoire du la Banque* (1981): 296–342.

*Washington Times.* "Fort Meade Was Site of POW Camp." December 7, 1999.

Weiss, Max, ed. "That's Amore." *Baltimore Magazine* (July 2005).

Zannino, Mimi. "The King of All that's Good and Italian." *Italian Times of Maryland* (November/December 1987).

# Baltimore Sun *Articles*

*Most* Baltimore Sun *articles were located online in the database of Enoch Pratt Free Library, Baltimore, Maryland.*

Alvarez, Rafael. "Fifty Years Ago, They Had Nothing: Prisoners of War." *Baltimore Sun*, February 21, 1993.

———. "Hurdy Gurdy Man's Grandson Keeps Memories Alive." *Baltimore Sun*, July 2, 1987.

Anthony, Nicholas J. "Life Was Hard at Saint Leo's Orphanage." *Baltimore Sun*, May 11, 1975.

*Baltimore Sun.* "Annual Spaghetti Suppers Are Still the Style at Saint Leo's." October 21, 1947.

———. "Card Group Goes Bocce." August 23, 1959.

———. "City Goes Wild Over Peace." Service Edition, August 19, 1945.

———. "Coming in February: A Spanish-Italian Restaurant in Little Italy." "Restaurant Notes," December 16, 1983.

———. "Glimpses of Baltimore: Little Italy." August 13, 1911.

———. "Italians in Baltimore." March 23, 1948.

———. "Larry J. Marino Dies." Obituary, January 7, 1981.

———. "Reagan in Baltimore." October 9, 1984.

Bliss, DeWitt, and Rafael Alvarez. "Nancy D'Alesandro Dies, Headed Political Family." *Baltimore Sun*, April 5, 1995.

Cerelli, Charles. "I Remember Hurdy Gurdy Music in the Air." *Baltimore Sun*, July 12, 1959.

Dawson, Jack. "Bocce: One of the Few Sports the Young and Old Can Play Together." *Baltimore Sun*, May 28, 1978.

Erlandson, Robert A. "Baltimore's Oldest Columbus Monument Regains Status." *Baltimore Sun*, May 21, 1992.

Fitzgerald, Stephen E. "Little Italy's Tribute to Saint Anthony." *Baltimore Sun*, June 12, 1932.

Gullard, Marie Marciano. "Dream Home: Malt House Condo Showcases Couple's Art Collection." *Baltimore Sun*, May 17, 2011.

Gunts, Edward. "An 1866 Malt House Is Being Refitted for Luxury Lofts." *Baltimore Sun*, September 26, 2005.

Kasper, Rob. "Grapesellers Attract Flow of Winemakers to Their Place." *Baltimore Sun*, October 9, 2002.

Kelly, Jacques. "Tacks, Brads, Nails Spew Out of Old Factory." *Baltimore Sun*, November 7, 1991.

Large, Elizabeth. "Eater's Digest: It's Sensible to Stick with Seafood at Sergi's Ice House." *Baltimore Sun*, April 5, 1974.

Olesker, Michael. "Little Italy Dispute Fades on Makeshift Movie Screen." *Baltimore Sun*, August 5, 1999.

Rodricks, Dan. "Little Italy Store Fails; Community Prefers Revco." *Baltimore Sun*, October 20, 1997.

Sandler, Gilbert. "Sun Shines on Saint Gabriel." *Baltimore Sun*, October 4, 1970.

Schoettler, Carl. "A Shower of Memories Bathhouses." *Baltimore Sun*, September 30, 1996.

Williams, Harold A. "Saint Anthony and the Baltimore Fire." *Baltimore Sun*, June 16, 1946.

Williams, Lynn. "Italian Markets: It's Only a Short Trip to Find Authentic Foods," *Baltimore Sun*, August 15, 1984.

## WEBSITES AND ONLINE RESOURCES

Baltimore Civil War Museum. "A Brief History of President Street Station." http://baltimorecivilwarmuseum.com/history.html.

Canal Street Malt House. http://canalstreetmalthouse.net.

Carroll Museums Inc. "What's in a Name? The Story of Jonestown." http://www.carrollmuseums.org/history/jonestownhistory.html.

Casebook. "War of 1812, Mary Young Pickersgill." http://casebook.thewarof1812.info/People_files/Pickersgill/people_summary.html.

Congresswoman Nancy Pelosi. "Biography." http://pelosi.house.gov/biography/biography.

D'Adamo, Joe. "Storia Nostra." The Little Italy Lodge. http://www.littleitalylodge-osia.org/site/history.asp.

*E.S.P.*, CBS Local's weekly newsletter. http://espguide.cbslocal.com.

Fort George G. Meade Museum. "Prisoners of War." http://www.ftmeade.army.mil/museum/Museum_POW_List.html.

Goist, David. "Dating Metal Tacks." Conservation Online. http://cool.conservation-us.org/byform/mailing-lists/cdl/1999/1121.html.

Hirst, Don. Fort Meade SoundOff!, posted August 23, 2007. ftmeadesoundoff.com.

Leshnoff, Jessica. "Century Paradiso." *Baltimore Magazine.* http://www.baltimoremagazine.net/old-site/people/2010/07/century-paradiso.

Maryland Historical Society Library Department. "Home-Made Wines Made of Dandelions: Prohibition in Maryland." http://www.mdhs.org/underbelly/2014/02/20/home-made-wines-made-of-dandelions-prohibition-in-maryland.

Maryland Public Television. "Impressions of Nancy Pelosi," October 10, 2013. http://video.mpt.tv/video/2365101090.

"Monument City" blog. "Christopher Columbus Statue in Druid Hill Park." http://monumentcity.net/2009/05/11/columbus-monument-at-druid-hill-park-baltimore-md.

National Register of Historic Places, Inventory Nomination Form, February 12, 1975. http://www.nps.gov/nhl/find/statelists/md/StarSpangledBanner.pdf.

New American Standard Bible, 1995. https://www.biblegateway.com/versions/New-American-Standard-Bible-NASB/#vinfo.

Poe Baltimore. "Mechanic's Row, Wilks Street." http://www.poeinbaltimore.org/poe-places.

Promotion Center for Little Italy, Baltimore. "Neighborhood News from Little Italy, Baltimore." http://www.promotioncenterforlittleitaly.org/newsletter.html.

United States Bocce Federation. "An Historical Look." http://www.usbf.us/history-of-bocce.html.

Zilberman, Maria. "It's Movie Night in Little Italy." *Daily Record.* http://thedailyrecord.com/2012/07/04/its-movie-night-in-little-italy.

## Personal Interviews and Archives

*Informal chats, phone calls, e-mails and face-to-face interviews were conducted with many folks connected to Little Italy who helped to fill in facts, details and anecdotes for this book.*

Baltimore Neighborhood Heritage Project interviews, 1979–82. University of Baltimore, Langsdale Library/Special Collections Department, Baltimore, Maryland (referred to throughout text as BNHP).

Jewish Museum of Maryland, Baltimore, Maryland.

# Index

# About the Author and the Photographer

We must live as who we were born to be and love who we are. I *love* being Italian. I'm a bricklayer's daughter, the third child of four born to Gina (Mossa) and Luigi Saver Molino Jr. I'm the granddaughter of four emigrated Italians from the Old Country—Vasto, Abruzzi, and Luras, Sardegna. I was raised the Italian way in Dundalk until age eight, and then it was on to Perry Hall. My father built that "house on the hill" with his two bare hands, a cement mixer and a clan of *paesani*.

Since 2001, I've been blessed with six visits so far to *Sardegna*, and I'm nowhere near finished. I speak basic Italian (but don't get fancy on me) and enjoy conversing with my cousins in Italy by phone, e-mail and texts. I'm always on the lookout for a perfect cannoli. Like most Italians, I enjoy my food—mostly my mother's.

Suzanna Rosa Molino. *Photo by Fred Singleton.*

Because my writing career always has been related to my passions, I established the nonprofit organization Promotion Center for Little Italy Baltimore in 2010, of which I am director. This pro bono post provides me the opportunity to engage fully with Little Italy and stay connected to Baltimore's Italian community. I have forged many fine friendships with residents and folks who grew up there and still return to serve at Saint Leo's and the Little Italy Lodge.

I find complete satisfaction in promoting the neighborhood's events and its components: Saint Leo's (as a parishioner), Little Italy Lodge (as a member),

bocce (as a player on Team *Cugini* with Molino cousins) and Pandola Learning Center (as a former student).

As a freelancer since 1995, my career has included event and editing/writing assignments in the nonprofit sector and writing stories for magazines and newspapers around the country. Between 2005 and 2009, I was a staff writer at the *Catholic Review*. Since 2006, I have written a weekly women's inspirational column, "SNIPPETS."

My husband, former Major League Baseball player Ken Singleton, and I live in Baltimore County, where we have raised four children. We are *nonni* to three grandbabies. When we married in 1991, I teased him that I was going to add a few vowels to his surname… *Singletonio*. Sounds nice, si? Did I mention how I love being Italian?

<div style="text-align:right">

–Suzanna Rosa Molino
*suzannamolino@littleitalymd.com*

</div>

T HOMAS "MAZZIE" C. SCILIPOTI has perfectly captured Little Italy and Baltimore in images for close to sixty years, specializing in black-and-white. More than twenty of the images in this book were provided from his collection. From Little Italy's Thomas D'Alesandro's inauguration to President Kennedy's arrival in Baltimore, from the sand lot at the old Scarlett Seed Building to Mickey Mantle's appearance in Roma's Restaurant, Tom tells a story with each photo, not only of its subject but also of the man behind the camera.

Tom, eighty-three, was born and raised in Little Italy (Pratt and High Streets) and first started taking pictures at age seventeen after his parents bought him a camera. Since then, he has been toting one everywhere, patiently waiting for that perfect shot. He is the unobtrusive figure at most Little Italy events.

Tom's parents and grandparents emigrated from Bafia, Sicily. He is a parishioner of Saint Leo's and also of Holy Rosary in Fells Point, where he resides. At each church festival, you can meet and greet Tom in the church hall, where he proudly displays and sells his work. View his images on baltimorepictureperfect.com.

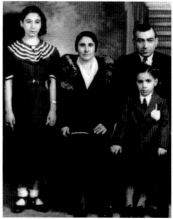

*Top*: Tom Scilipoti. *Bottom*: Tom, age seven, pictured with his parents, Dominica and Mario, and sister, Josephine, in 1937. *Courtesy Thomas C. Scilipoti.*